intro

0.1

0.2

0.3

0.4

0.5

0.6

0.7

0.8

0.9

1.0

1.1

1.2

endmatter

>

Editorial Design

FOR PRINT AND ELECTRONIC MEDIA

YOLANDA ZAPPATERRA

RotoVision

A RotoVision Book

Published and distributed by RotoVision SA
Rue du Bugnon 7
CH-1299 Crans-Près-Céligny
Switzerland

RotoVision SA, Sales & Production Office
Sheridan House, 112/116A Western Road
Hove, East Sussex BN3 1DD, UK

T +44 (0) 1273 72 72 68
F +44 (0) 1273 72 72 69
E-mail sales@rotovision.com
www.rotovision.com

10 9 8 7 6 5 4 3 2 1

ISBN 2-88046-718-7

Book design by Mono
www.monosite.co.uk

Production and separations in Singapore by
ProVision Pte. Ltd.

T +65 334 7720
F +65 334 7721

Printed in China by Leefung–Asco Printers Ltd

contents

>

> 1
Adbusters Magazine

> 2
Tate Website

> 3
Tokion Magazine

> 4
wallpaper* Website

> 5
Nest Magazine

> 6
Dishy

> 7
Utne Reader Magazine

> 8
I.D. Magazine

> 9
Play CD-ROM

> 10
Designing Web Graphics.3

> 11
Earthwatch Website

> 12
My BBC Website

intro

>

Editorial design is without doubt one of the most exciting and innovative areas of design at the moment. From exhibition catalogues and on-line magazines to newspaper supplements, books and the thousands of independent magazines being published both on- and off-line around the world, editorial design has benefited a great deal from the advances in digital technology. Just a few years ago, industry analysts and publishers believed that digital technology and its new medium, the internet, could sound the death knell for print publications. Yet on-line design has acted as a catalyst for print designers, many of whom now work in both disciplines and are allowing one area to inform the other. Anyone can now put out a publication – on- or off-line – using DTP or authoring tools; in terms of design expression it's one of the purest forms of design available and offers the widest creative freedom – assuming you can meet the demands of a broad range of masters.

A main feature of **Digital Lab: Print & Electronic Design** is the deconstruction not only of the creative process but also of the production process behind a project. This is done largely through the voice of the designer, but also by incorporating comments from those professionals who form some part in realising the designer's vision. This is particularly apposite to the understanding of editorial design, a discipline in which many elements need to interact harmoniously to form a cohesive whole; it involves the designer juggling creative elements such as photography, typography, text and illustration, but it also involves them juggling constraints and demands from editors, publishers, advertisers, repro houses, printer and paper mills – and that's before the reader even gets a look in. Other forms of editorial design pose equally complex design dilemmas: for example in website design, the constraints and problems of programming, font use, Web-safe colours, download times and plug-in availability present the designer with different, but equally intriguing creative problems.

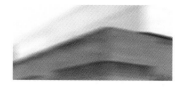

The bulk of the projects here fall into one category; magazines. Early on, however, I made the decision that ultra-slick corporate magazines, those whose content and design is often dictated more by its advertisers than its art director and editor, were not something I would focus on; having worked for a good number of such hierarchical publications I know that everything has to be approved by the publisher, lawyer and marketing department, which renders explanations and exploration of creative process and development little more than bland promo pieces offering little if any genuinely intelligent insight. Instead I turned to those respected magazines who break boundaries, break the rules and even break the mould. One brilliant example is the widely acclaimed Canadian independent bible for culture jammers, Adbusters. No publisher, no ads, just vital and vibrant discussion of consumerism and the role design and communication plays in its dissemination, delivered via a striking design that consistently undermines and subverts consumerism in general and the magazines that promote it in particular.

From there it's a strange route to the new website launched by Wallpaper*, superficially the bible of consumer culture but beneath the glossy surface a celebration of great architecture, craftsmanship and design in all its forms. Eschewing the celebrity profiles and puff pieces, Wallpaper* has been a publishing phenomenon – could its website have as great a design impact? Editorial director Tyler Brûlé. whose unerring eye for great design and almost fanatical attention to detail has ensured the print version remains consistently innovative, worked closely with designers I-D Media Gruppe to ensure its design direction would reflect the monthly print magazine, but also utilise the added functionality that interactivity can bring.

The inclusion of the Wallpaper* site raised the problem of redundancy in technology; by the time you read this, almost a year on from my writing it, the programs and software being used by those designers who have embraced the digital age and the creative expression it allows, i.e. all those in this book, will have been outmoded and updated. For this reason I chose to touch on – but not fixate on – the software used in creating these projects. Time and time again designers have told me the computer and its attendant technologies are tools that facilitate their work and enable them to realise their creative potential and ideas, but ultimately they are just tools. Without the technology these designers would still be designing, still putting myriad number of elements together to arrive at something that informs, elucidates, educates, delights and inspires; they would still be creating the kinds of editorial excellence shown in these pages.

project 0.1 adbusters

While researching projects for this book I asked a leading Canadian journalist if his birthplace had any great magazines, apart from Adbusters. No, he replied. Nothing came close to it. His countrymen obviously agreed, as in 1999 the Canadian National Magazine Awards gave its magazine of the year award to Adbusters, the counter-culture magazine which has been successfully 'culture jamming' for almost a decade now, and is going from strength to strength. Based in Vancouver, British Columbia, Adbusters is a not-for-profit quarterly magazine which mounts campaigns like Buy Nothing Day and TV Turnoff Week on its own and with the likes of Friends of the Earth, and boasts a healthy circulation of 60,000, many of whom send contributions to help keep the magazine independent, pay legal bills and stylishly fight against the rampant consumerism of our society.

Amazingly, Adbusters' readers span 60 countries – something that few magazines come close to except, ironically, wallpaper* – and come from all walks of life; the magazine lists its reader profile as "professors and students; activists and politicians; environmentalists and media professionals; corporate watchdogs and industry insiders; kids who love our slick ad parodies and parents who worry about their children logging too many hours a day in the electronic environment."

While Adbusters' incisive, intelligent and acerbic content, incorporating philosophical features and international activist news and commentary, undoubtedly explains in large part its popularity, its design ethos shows a complimentary strength and originality that makes it as compelling as the content. Indeed, the visual content, from fashion satire and advertising parodies to multi-textural photo essays and subtle undermining of lifestyle bibles, amounts to a gleeful and visually arresting attack on our branding- and marketing-obsessed culture.

A large part of Adbusters' inclusion here as an outstanding editorial design project is based on the fact that the witty approach doesn't detract from the magazine's message; indeed, reinforcing the direction and aim of the magazine, which is best expressed by its editor Kalle Lasn as "an ecological magazine, dedicated to examining the relationship between human beings and their physical and mental environment. We want a world in which the economy and ecology resonate in balance. We try to coax people from spectator to participant in this quest. We want folks to get mad about corporate disinformation, injustices in the global economy, and any industry that pollutes our physical or mental commons."

Art director Chris Dixon agrees: "Adbusters is a journal that tries to counter-balance the current flow of information and entertainment flowing out of today's landscape of mass media. It tries to show another world view which does not revolve around consumerism and celebrities. And we try to do it while looking sophisticated and confident rather than like the underdog." Dixon is at pains to point out that the "design itself is not anti-corporate." Instead, he believes it plays its part in the magazine's anti-corporate values "by just supplying people with organised, contemporary, intelligent design, and letting the articles and photographs speak loudly; the design helps with the message delivery."

Dixon is unequivocal on the dual nature and purpose which inform the magazine's design direction and ethos: "It's trying to find a balance between an experimental art/photography book and a newsstand magazine. We like to try to find new ways of communicating and combining our image and text, but we need to appeal to a mass audience as we are in the business of mass change. So that's the tension. But I think we are doing a good job. Even with our somewhat experimental approach, the circulation has doubled in the last two years, up to 60,000. So that many more people are reading about what we think are important ideas." In a world dictated by how things look rather than what they're saying, selling or promoting, it's good to know that a campaigning magazine can take that cynical approach and re-purpose it to produce something that looks good *because* of what it's saying and promoting.

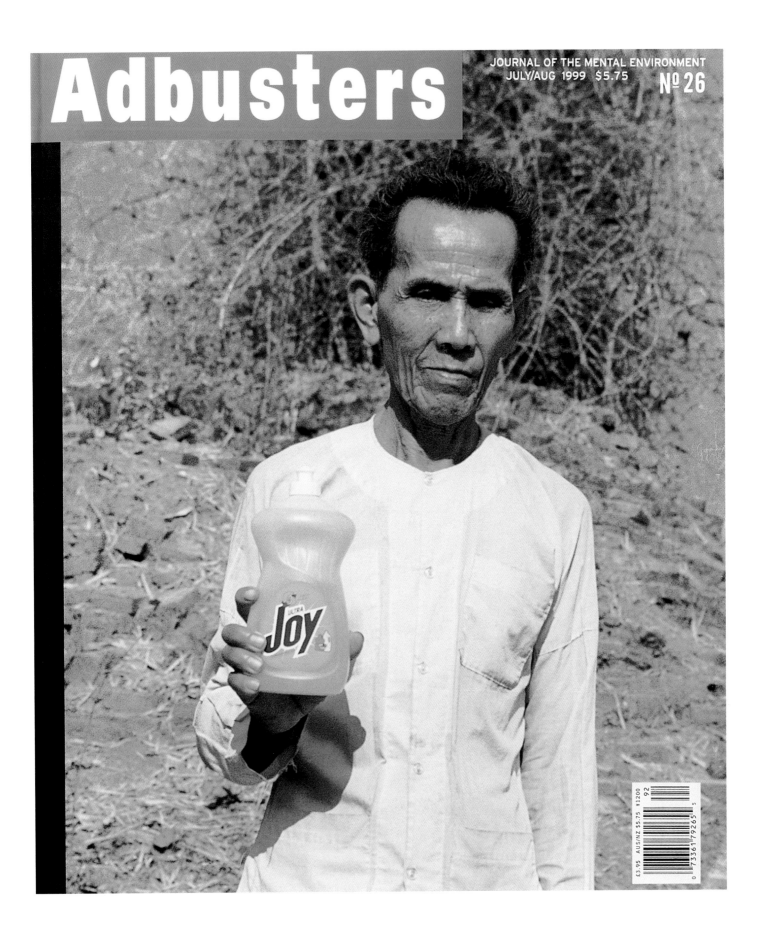

Adbusters

JOURNAL OF THE MENTAL ENVIRONMENT
JULY/AUG 1999 $5.75 № 26

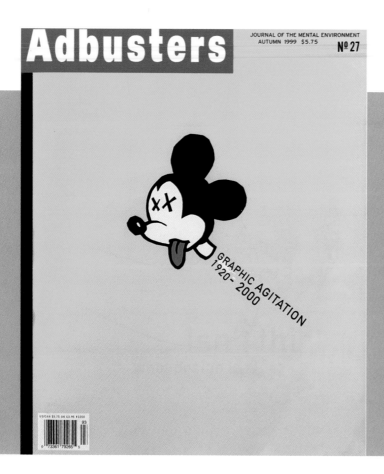

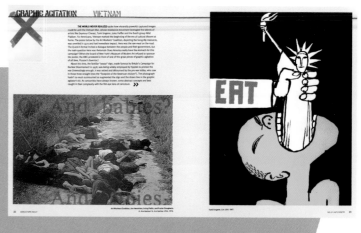

0.1 themes

Adbusters art director Chris Dixon and editor Kalle Lasn begin each issue with a broad theme and start to collect visuals and stories, as the cover and spreads from the autumn 1999 issue show. "We structure it so there are 'flows', long sections where images and text work to tell a story. And then the cover, back cover and so on all start to pick up on these themes and so hopefully it all ends up tying together. We hope each issue is like a complete snapshot of the theme. Covered from all angles."

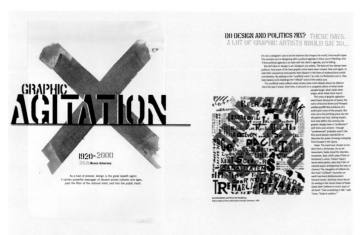

0.2 contents

Dixon is emphatic that the content determines the whole look of each issue. "The content and visuals are developed hand in hand, so they affect each other. It's not as simple as content equals form. In the end the whole thing should project a mood, a tone, which best encapsulates the theme of the issue," he explains.

0.3 contents page ↓

Three years ago Dixon decided to do away with the contents page: "It was breaking up the flow of the long photo essay which led nicely into the main story. It takes away from the organic nature of a publication. And it dictates exactly how one should approach the issue, when really the reader could come at it in many ways. So we cut it. The editor felt that it segmented the whole issue too much. Like a bunch of little sausages coming out of a machine. That's why we cut it… because of the sausages."

0.4 navigation ↓

With no contents page, the only navigational aids in the magazine take the form of colour blocks on the various 'non-feature' sections such as Battle, News from the Front, Calendar End Games and In Your Face. Dixon describes the blocks as "signifying areas of the magazine which are made up of short, quick news-like stories, the media landscape. So the colour bars express this in their variety and choppiness. They show that you are not in the middle of a longer thematic flow, but in a very separate section."

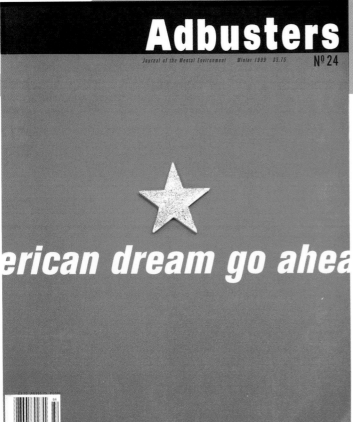

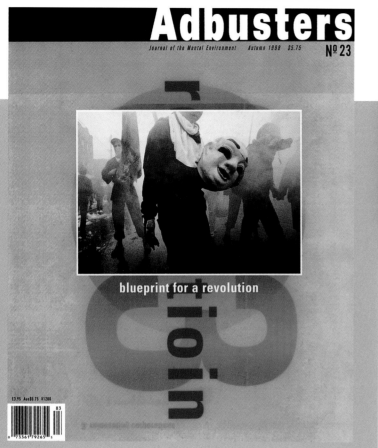

0.5 structuring

Around issues 22 to 24 a number of design changes took place, including the loss of the contents page and editorial comment and changes in grids and fonts. "We decided that rather than try to be as formatted and structured as a typical news-stand magazine, we should really try new ways of structuring and presenting our content. So we decided that although it was not proper 'magazine formula' we would treat each issue as a separate entity, and design it as such. We can do that I think as a quarterly, because it is almost like a mini-book coming along every three months. So then each issue was just given its own typefaces, grids, colours, depending on the theme, the size of the issue, the amount of money we had for photos, illustrators and so on. As a small magazine with a small budget, you have to be flexible. So we decided not to fight it," explains Dixon.

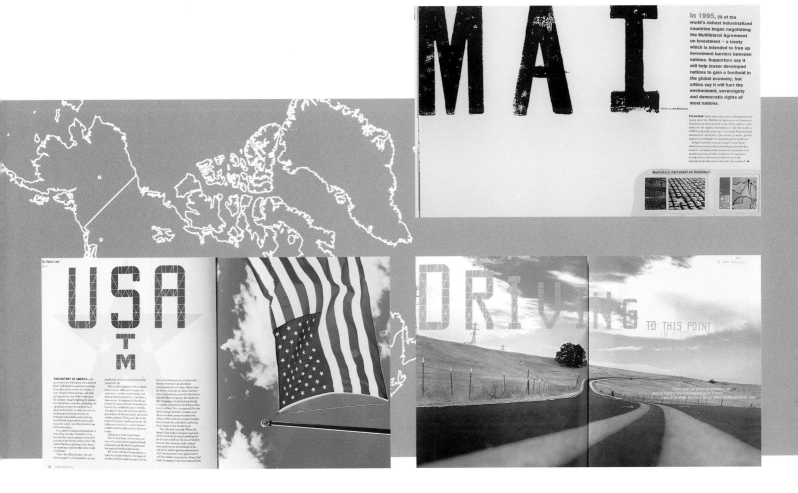

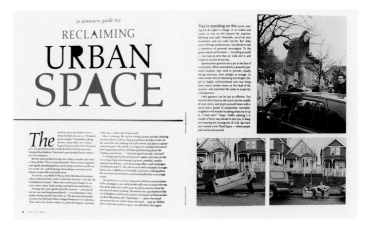

0.6 grids

"Grids change with each issue, though they're mostly three column. I must admit I don't pay much attention to grids, or grid theory. Not out of any ideology, I'm just hopeless at any sort of mathematical equations."

0.7 fonts

Body copy fonts are usually Meta, FF Scala… "and sometimes Univers", says Dixon. For display fonts he follows "the Rolling Stone formula of every story having its own personality and being treated uniquely. As well, I choose particular fonts for a theme issue, for example in the Spring 2000 issue, themed around space, all the features used the same display font treated in different ways," he adds. (Compare 'Reclaiming Urban Space' here with 'Empty Spaces' overleaf.)

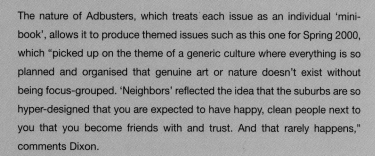

0.8 themed issues

The nature of Adbusters, which treats each issue as an individual 'mini-book', allows it to produce themed issues such as this one for Spring 2000, which "picked up on the theme of a generic culture where everything is so planned and organised that genuine art or nature doesn't exist without being focus-grouped. 'Neighbors' reflected the idea that the suburbs are so hyper-designed that you are expected to have happy, clean people next to you that you become friends with and trust. And that rarely happens," comments Dixon.

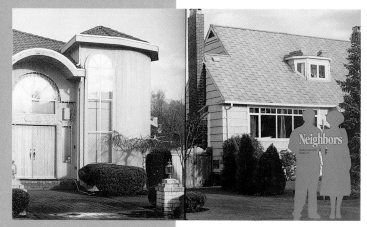

{empty}

SPACES

As a child I played in "empty spaces." Everyone has. These places are gaps between buildings, ruins of buildings, fallow land, abandoned industrial areas, gravel pits and sand mines. Formed through misplanning, they were our empire, the empire of children. I can remember one of these "playgrounds" very well. It was not far from my parents' apartment, perhaps as far as I could throw a stone. It was very big, maybe the size of a soccer field, and it was our own empire, with our own laws — the laws of children. This place also served as a shortcut to school, but was often the reason we

These people called themselves "landscape designers" and "city gardeners." The names are too kind. They should be called "terminators of life" or "killers of the empty spaces." They not only exterminated our playground, our footpath, our shortcut (transforming it into a monotonous green meadow) but they also diverted our brook and replaced it with a fountain of concrete cubical forms of different sizes, which was intended to symbolize "being together." I still don't understand it. My mother told me, "it is so-called art."

This story of my "empty space" is not an isolated case: there are examples wherever you look. The reason I remembered the story

0.9 features ↗

All the issues in the Spring 2000 Adbusters are further explored in the stories, while three spreads, including 'Empty Spaces', shown here, cover three related topics; suburban space, commercial space and urban space. "All the feature stories shared the same look; clean, black and white classic book typography, all of which served to feature the very sterile, static, and removed photos. So 'Empty Spaces', with photographs by Scott McFarland, had the same; any type treatment that was expressive or colourful would have overpowered the elegance of the photos."

1.0 imagery ↗ ↘

To achieve the widest possible use of imagery on a small budget, Dixon uses a combination of "great photo-journalism from agencies like Magnum, existing art photography which fits in with our issue, and working in Vancouver with photographers", including Mackenzie Stroh who shot these pictures for two issues of Adbusters. "I only use maybe four to five photographers here, and they all are totally in tune with the style and message we work towards. Very intelligent artists. I go over the text with them, and then we go out and shoot together. We try to get a huge variety and then edit down. Usually the best moments happen when you are just playing with the photos and magic happens when two are placed together. I believe in happy accidents, and letting a photo essay take on a life of its own, so we don't tightly organise our shoots," says Dixon.

1.1 pull quotes

The winter 2000 issue of Adbusters is a good example of what Dixon calls happy accidents. Two elements, a fiction story by Bob Rich and transportation photos, were both floating around during the development of the issue as separate pieces. "When put together we realised that the photos really got to the heart of Bob's story, which was about modern living, mass culture, families struggling, a whole culture struggling. So we then edited it a bit more and put the pull quotes on to the photos, for example 'I'm one of them' over the tyres, which connected them a bit more and really gave the piece a philosophical edge. Kalle kept pushing this one and I think it finally came together. We started it with Martin Parr's double page shot of the man in the car then finished it with the man looking at the camera to give it a personal feel that the reader could connect with."

1.2 production

The production process of Adbusters is quite straightforward. Having put together an analogue mock-up, Dixon uses QuarkXpress to make all the roughs. All the photos and illustrations then go to prepress to be drum scanned. "I build up a folder on my G3 hard drive that contains the whole issue; it usually grows to 2Gb. And then it all gets placed into Quark and I do layout there, put it all on two jaz discs and send it to the printer. Then we do computer-to-plate and look at rough colour proofs before printing in Toronto," says Dixon.

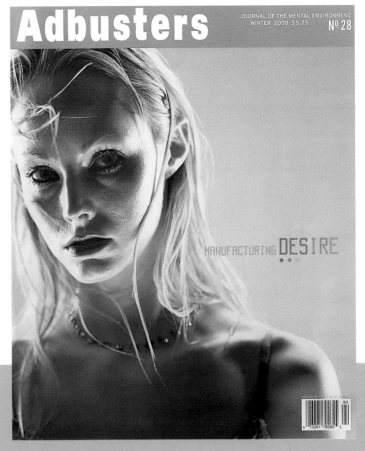

1.4 circulation ↑ ↓

The magazine's ability to satirise both style magazines and consumerism is becoming more and more subtle and skilful, as these early covers, compared with the much later summer 1999 and winter 2000 covers, show. Perhaps it's this growing sophistication that accounts for the magazine's circulation doubling in two years – or perhaps the agitprop message, married with great design, is finally getting across.

1.3 advertising parody ↑

Advertising parody is one of the things Adbusters is famous for and one of the reasons, according to editor Kalle Lasn quoted on the magazine's website, for its appeal across such a wide readership.

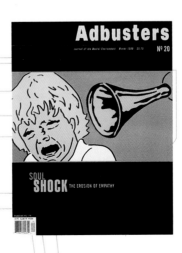

Kalle Lasn, Adbuster's editor

comments

project credits

Editor Kalle Lasn

Art Director Chris Dixon

Art Assistant Anne Saint-Louis

Adbusters
1243 West 7th Avenue
Vancouver
BC, V6H 1B7
Canada

T +1 604 736 9401
F +1 604 737 6021

E-mail adbusters@adbusters.org
www.adbusters.org

Kalle Lasn, editor

"We've been going for ten years but our big breakthrough came with the 'Blueprint for a Revolution' [Autumn 1998] issue. And it was all because Chris Dixon and I had a fight! Almost since the beginning of Adbusters we've had this phrase kicking around: 'slick subversive'. We wanted the magazine to be slick subversive. Chris, like most designers, had been taught traditional editorial layout, a system that lets the art department take over and turn the magazine into something that looks like advertising. There was something about that approach that both of us were uncomfortable with and we started talking about it. We talked a lot about flow. We talked about Colors and Tibor Kalman and how we wanted Adbusters to be a very coherent, political Colors, but without the reliance on photographs. Tibor once did an issue of Colors that was entirely photographs – very inspiring, but Adbusters has got a lot to say."

"Adbusters is the magazine of the culture-jamming revolution. What we have to say is about current popular culture – what's wrong with it, how we can jam it, how we can change it. We feel that consumer culture is unsustainable, dysfunctional, psychologically corrosive. Our aim is to create a new non-commercial culture from the ashes of consumer culture. We want to promote revolution in an inspiring way."

"So Chris and I argued a lot about the role of a designer. I was a film-maker for 20 years and was always hot on the concept of the film-maker as auteur, allowing your guts to spill on to the celluloid. I think that there should be the same kind of effort between editor and designer. It's not good enough for a designer just to be the one who prettifies the editorial content. This is exactly what's wrong with design right now: designers play such a crucial role in creating the tone, feel and texture of post-modern existence, but somehow they exist in a high-level aesthetic space where content doesn't matter. The fact they may be helping to create climate change, for example, doesn't seem to bother them. We decided to take a plunge, to break the tradition. We just went wild. We took out the contents page. What does a table of contents do? It breaks up the flow. That goes against our philosophy. We took out the templates. We created something with a seamless, comic book flow that allows the reader to explore their mental environment in a much more intimate way. We decided to treat every issue as a one off, a one-time performance. Get an idea and go for it. We go with it because we all feel it in our guts. We can do anything we want because we don't rely on money from advertisers."

project 0.2 tate website

With the renovation and invigoration of the Bankside area opposite St Paul's Cathedral, London saw a cultural renaissance in 2000 which drew as much praise and admiration as the beleaguered Millennium Dome did derision and anger. Alongside Shakespeare's Globe Theatre and facing the troubled new Millennium Bridge is one of the newest, largest and most exciting galleries to open for decades, Tate Modern. The original Tate gallery stands on one site in Pimlico and the arts organisation later opened two regional sites; one in the city of Liverpool and the other St Ives in Cornwall, the location of a long-standing artists' colony. With the opening of the latest gallery the Tate has rebranded itself, with the help of international consultancy Wolff Olins, into an overarching organisation called simply 'Tate'. The four galleries are now known as Tate St Ives, Tate Liverpool, Tate Britain and Tate Modern. Their names derive from their locations and their collections. Tate Britain, based on the original site in Pimlico, displays a large collection of British art ranging from 16th century to contemporary. Tate Modern displays international modernist and post-modernist masters. All the galleries host changing exhibitions as well as their permanent displays. Part of the rebranding process was a relaunch of the Tate's website (www.tate.org.uk) by leading multimedia design company Nykris Digital Design.

Nykris Digital Design was founded in 1997 by Nikki Barton and Chris Prior; the company name is a contraction of their first names. Their client list includes such names as Intel, ONdigital, BBC, Oxfam, Oxford University Press, PricewaterhouseCoopers, Richard Rogers Partnership and Unilever plc. Nykris also redesigned the interface for Microsoft's Internet Explorer 5 on the Mac platform, utilising graphic elements from the ground-breaking iMac design. Nikki Barton, creative director at Nykris Digital Design, explains how their involvement in the Tate site began: "We were one of four agencies approached by the Tate's representatives. We had a meeting just before Christmas 1999 and were told at the beginning of January 2000 that we had been selected to redesign the site. The project was offered and undertaken on the understanding that it was a very tight schedule and an immovable deadline, with go-live on March 24th 2000, the opening date for Tate Modern. The first design meeting took place mid-January, thus the project took just over two months from start to finish."

The Tate wanted a complete redesign of its existing site, which was already receiving between 4.5 and 7.5 million hits per month from over 140 countries. Barton continues: "The aims were to redesign the existing Tate website, giving it a clean and stylish contemporary look that compliments the new Tate corporate identity. But the site also had to harness the power of the internet to disseminate and project the new brand's message to a global audience and provide the foundation for the future development and expansion. It had to give detailed gallery information in a clear and attractive manner and allow the public on-line access to the Tate's collections. As far as marketing was concerned, the site had to build international awareness of the Tate, attract visitors and supporters and fundraise by increasing sales and attendance for exhibitions," she explains. "The Tate offers access through the site to thousands of works in its collections. This database is fundamental and fulfils one of the gallery's central tenets; access and education to the public," she adds.

Nykris Digital Design met with the brand designers Wolff Olins and the Tate was consulted regularly throughout the design process. Barton again: "We were given complete freedom in terms of the design of the site. However, we are always aware of the importance of retaining a consistent branding across all media, having worked on many projects in the past where strong brand values were of key importance. The new site has already proved itself to be highly popular worldwide; it actually gets more hits from the US than the UK. This gives a perfect illustration of how the Web can be used to give galleries and museums a much wider audience than would normally be the case. Gaining visitors on-line fulfils part of the remit of widening the accessibility of the gallery's works, and also translates into increased visits to the physical galleries and increased revenues from on-line shopping." With only two months to complete a mammoth site of over 600 pages and support such a diverse and fundamental set of obligations under one design umbrella, Nykris Digital Design has successfully pulled off a minor miracle. The prestigious British Interactive Multimedia Association (BIMA) obviously thought so too when it presented the agency with its award for Community Service On-line earlier this year. It's a measure of Nykris' growing stature and recognition that the nomination was just one of five.

0.1 corporate identity

The new Tate corporate identity, created by Wolff Olins, uses four brand marks for the four different real world sites of the galleries. By randomly making use of all the different marks, the Tate site will "always be fresh, always fluid, always different but always Tate." (Wolff Olins, Tate brand values)

BRITAIN MODERN St IVES LIVERPOOL
TATE TATE TATE TATE

0.2 colours ↗

Wolff Olins had recommended ten colours in the brand toolkit that should be used and Nykris Digital Design worked with these to determine which colour schemes were used throughout the website. The ten colours in the palette provided were not Web-safe so they were adapted to fit the restricted Web 216 colour palette.

0.3 design ↗ ↓

Nikki Barton, creative director at Nykris Digital Design, explains "we wanted to create a design for the site that is everything a modern website for this kind of organisation should be; contemporary and modern and also clean and simple to use, with information presented in an exciting and interesting way. The site had to be open and welcoming, efficient and available to all visitors, while always retaining a strong sense of branding and design. When first arriving at the site, the splash page may be sky-blue, orange, scarlet or violet and the accompanying mark may be one of four versions. Further into the site the colours remain consistent with the area you are in; orange for Tate Britain, sky-blue for Tate St. Ives, scarlet for Tate Modern and violet for Tate Liverpool."

0.4 elements ↗

Colour is just as important in the generic pages, for example, the collections are coloured slate and the home page is purple. "The new branding allows for a number of colours and marks to be used and we have taken care to create a design that incorporates this flexibility and where appropriate used the new, specially created typeface 'Tate' as a graphic element throughout the site," says Barton. The front page grid is different to the gallery page grids, featuring three columns with the right hand one reserved for navigation, a consistent feature throughout the site. The left-hand column contains highlighted gallery information and the central column contains featured content and articles. The grids on subsequent gallery pages are simpler and have only two columns; the main content area and the right side navigation panel. The top row, which is reversed out, contains flash animations or animated GIFs and is an area where the more dynamic content appears together with the branding. There is also an area in the upper row that relates to a higher level of navigation across the main divisions of the site – such as home, shop, supporters and feedback.

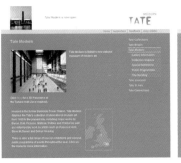

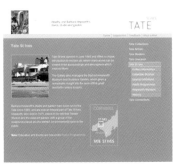

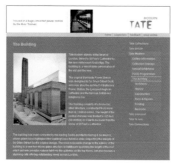

0.5 navigation

Navigation had to be completely transparent and immediately obvious as the site has over 600 pages. The design has been kept open and clean with page layout and menu positioning constant throughout to prevent the user becoming lost. Clear indication is always given of which section the user is in and how to access the other sections, allowing the user to locate the information required with the minimum number of clicks.

Admission

Admission to the Gallery is free, but donations from visitors are needed to support the Gallery's work. You can also help by visiting the Shops and Cafés or by joining Tate Friends. The Supporters section of this site gives more information about how to help the gallery financially and the benefits that supporters gain.

Getting Here

Tate Modern is located on the south bank of the River Thames at Bankside, near Blackfriars Bridge, opposite St Paul's Cathedral and next to the Globe Theatre.

0.6 fonts

As the main text content had to be dynamic, the choice of typefaces in which it could be displayed was limited to the fonts most likely to be installed on the user's machines. For text not displayed as graphics, where the specially created typeface 'Tate' was used, it was decided that the clearest and most appropriate typeface was Arial. However, there are further options if Arial is not installed. The order of preference is Arial, Helvetica and then Verdana. All copy was supplied by the Tate.

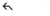

0.7 animations ↗

Pictures and animations are in JPEG, GIF and Flash formats. Although Flash is used extensively the site is not reliant on it. A JavaScript checks for the presence of the Flash plug-in and if it is absent it will then check to see if the user has QuickTime, which will also play Flash movies. In the absence of both plug-ins, animated GIFs are displayed. All of this testing for plug-ins happens invisibly, ensuring a seamless experience throughout when viewing the site. JavaScript also handles roll-overs and back-end scripting for the database. The Tate supplied pictures of their collection from their database in suitable web format.

0.8 programming ↙

Clever programming ensures that upload speed is maximised, and the streaming of Flash animations allows the beginning of an animation to play while the rest of it is still loading. By extensive use of caching, speeds improve on subsequent visits to the site. All graphical elements were extensively tested to ensure the smallest file size possible. The Tate's brief took into account legacy browsers and systems, allowing everyone as rich an experience with the site as possible. New smart browsers mean that style sheets can be applied, giving a more consistent look across computer platforms and different browsers. Style sheets also elegantly simplify the HTML code, reducing the chance of errors when updating the site. Software used was BBEdit, Hypercard, Photoshop, Macromedia Flash, Macromedia Fireworks and Adobe Illustrator in the development and creation of the Tate site.

```
.stives2 A:link {
    COLOR: #69c; TEXT-DECORATION: none
}
.stives2 A:active {
    COLOR: #bde; TEXT-DECORATION: underline
}
.stives2 A:visited {
    COLOR: #69c; TEXT-DECORATION: none
}
.stives2 A:hover {
    COLOR: #bde; TEXT-DECORATION: underline
}
</STYLE>
<FONT class=bodytext color=#333333 face=Arial,Helvetica,Geneva><IMG
height=14 src="Tate_Home_files/transparent.gif" width=552><!-- Spacer for top of page --></FONT>
<TABLE border=0 cellPadding=0 cellSpacing=0 width=572><!-- Start Content Table-->
<TBODY>
```

0.9 brief

"Our initial brief from the Tate was to create a site that was easily maintainable and updateable. The code for the pages had to be extremely clear with no superfluous code, and each element of it was tagged with a description to show exactly what it did. The structure and programming of the site are extremely clear and well thought out. The Tate has one part-time member of staff dedicated to the upkeep of this huge site, which carries much time-sensitive information. Updating of the site has been made as simple as possible," recalls Barton.

1.0 update

To help the Tate update the site, templates were created with guidelines to colour and type, allowing them to add pages as needed, but still keep with the overall scheme. Barton again: "There is a strength in the simplicity of the design and a flexibility that allows for the bottom of the page to be a solid bold colour (as appropriate to the section you are in) or a reversed version when the top of the page is coloured and the bottom is white. This allows for the Tate to pick and choose the template they wish to use without compromising the design or the artworks. The curators were keen to have the option of showing the artworks against a white background."

British art and modern art

home | supporters | contact us | shop online

A B C D E F G H I J K L M N O P Q R S T U V W Y Z

General Collection | Artists A-Z | Artists B | Sir Nathaniel Bacon

◀ Previous Artist ▶ Next Artist

Sir Nathaniel Bacon 1585-1627
British
Artist Biography

Cookmaid with Still Life of Vegetables and Fruit T06995 Has Image
(circa 1620-5)

Tate Collections
General collection
Oppé collection
Search collections
Archive
Library
Study Room
Tate Britain
Tate Modern
Tate Liverpool
Tate St Ives
Tate Connections

1.1 interface

The collection's on-line interface is designed around the Tate's main curatorial Oracle database, giving access to 25,000 records and 8,000 images maintained by the Tate. It allows for both simple and complex searches. Nykris Digital Design worked with the Tate to create search pages and templates that could be integrated with their database with the minimum of fuss. The database then directly updates the website as and when new entries are added.

Search Tate Collections

TATE

home | supporters | feedback | shop online

Tate Collections

The Tate houses the national collections of British Art and of international modern art

There are almost 25,000 works listed on this site, each with its own information page. To find particular artists and works you are interested in, try the new Search facility:

- the Simple Search uses artists' names and work titles
- or use a wider range of criteria in the Advanced Search

Alternatively you can browse the Tate's General Collection using an A-Z list of artists. You can also browse The Oppé Collection, a group of British watercolours, drawings, oil sketches and prints from the seventeenth, eighteenth and nineteenth centuries formed by the distinguished scholar Paul Oppé.

Currently around one third of the works in this section are illustrated, and we are adding an average of 500 new images to the site every week. This means that by the end of 2001 the entire Tate collection of over 50,000 images, including works on paper from the Turner Bequest, will be on the site.* This is part of a major new Tate initiative called the British Art Information Project, supported by the Heritage Lottery Fund as part of the Tate Britain Centenary Development.

Please note that some images cannot be shown for copyright reasons, but we are working actively to develop new agreements with copyright holders.

The Collections

The collection of historic British art ranges from the sixteenth century to the present day. Highlights include major works by Hogarth, Gainsborough, Reynolds, Stubbs, Wright of Derby, Blake, Palmer, Constable, the Pre-Raphaelites, Whistler, and Sargent. Home to the Turner Bequest, the Gallery holds the largest collection of paintings, drawings and watercolours by JMW Turner.

The collection of international modern art features important works by artists such as Picasso, Matisse, Duchamp, Epstein, Spencer, Mondrian, Gabo, Nicholson, Hepworth, Moore, Magritte, Dalí, Giacometti, Dubuffet, Bacon, Pollock, Rothko, Warhol and Beuys. The collection also includes works in all media by leading contemporary artists in Britain and from around the world, for example, Freud, Richter, Hamilton, Horn, Hirst and Whiteread.

Further research

The Tate Gallery Library, Archive and Study Room contain material which complements the Tate collections, and may be visited by appointment.

There are several Tate works that do not appear in the Collection database, these are listed below.

Artist: Whistler R
Title: The Expedition in Pursuit of Rare Meats
Date: 1926-7
Other Information: Restaurant mural

Artist: Anrep B
Title: Blake's Proverbs
Other Information: Mosaic pavement in Gallery 2

Artist: Bossanyi E
Title: The Angel Blesses the Women Washing Clothes
Date: 1937-42
Other Information: Stained glass window, Commissioned and presented by private subscribers with assistance from the Benson Fund 1940

Tate Collections
General collection
Oppé collection
Search collections
Archive
Library
Study Room
Tate Britain
Tate Modern
Tate Liverpool
Tate St Ives
Tate Connections

TATE

home | supporters | feedback | shop online

Search the Tate Collections online

You can now search the entire Tate Collections database to find the artists and works you are particularly interested in. There is a Simple Search below, or you can use a wider range of criteria in the Advanced Search.

| Simple Search | Advanced Search |

Artist Name
Work Title

[Search]

Tate Collections
General collection
Oppé collection
Search collections
Archive
Library
Study Room
Tate Britain
Tate Modern
Tate Liverpool
Tate St Ives
Tate Connections

Notes:
You may fill in one or more fields
You may use multiple words separated by spaces or commas
The search returns only works that **match all** your search terms,
You may use partial words - eg a search for 'wood' will also find 'woodland'.

Tom Betts, Tate's on-line editor

comments

project credits

Creative Director Nikki Barton

Technical Producer Graham Bartram

Interactive Designer Jason Fawcett

Interactive Producer Shashi Desai

Nykris Digital Design

Nykris Digital Design
The Worx
16–24 Underwood Street
London N1 7JQ
UK

T +44 (0)20 7250 1650
F +44 (0)20 7250 1651

www.nykris.com

Tom Betts, on-line editor

Originally an art school graduate from Goldsmiths College, Tom Betts has worked as a freelance programmer and designer for clients such as Microsoft and Cellnet. He has been working for the Tate for almost two years on a part-time basis and continues to work as a freelance designer and musician. He works closely with Nykris to ensure content and design of the site remain consistent, up-to-date and true to the Tate ethos and sensibility. Here he outlines how that's done.

"The site is updated continuously with changing events and updated gallery information," explains Betts. "Larger projects are prepared off-line for exhibitions and uploaded for the opening dates. We also carry out regular site-wide sweeps to remove out-of-date information and keep things current. Perl scripts need generating and modifying from time to time, the collections database system needs some maintenance and site statistics are processed monthly. Nykris has provided us with HTML templates that style the different sections of the site by colour and layout. Occasionally we will modify the design but in general the initial templates allow for a lot of flexibility. Content is then designed to fit within the relevant areas. The introduction of a content management system would benefit the site immensely. The design Nykris delivered is in a very flexible format and makes standard updating a relatively easy task. More complex or unusual projects obviously need more detailed work."

Betts continues: "We oversee the development of any new Web material and in most cases take on the production role of on-line projects. A few projects are carried out externally, but in general the copy and content is processed through us. Some copy comes from other media, such as printed leaflets, and is often of a reasonable length for translation to the Web. However sometimes we have to edit down text to fit the site or change the tone for a more Web-friendly approach. Collection and display information is taken from the database, but all other content is coded in HTML and uploaded manually. We are currently running an extensive project to scan in the majority of the collection works, of which we then provide Web images at several different resolutions. The work of adjusting and preparing these scans is carried out by trained professionals and should result in more and more of the collection being available digitally to the public, barring any copyright issues! I feel that the Web is evolving into an ideal medium for the vast number of communications needs of any large organisation and as such it should be recognised and resourced accordingly."

project 0.3 tokion

Japanese lifestyle magazine Tokion first caught my eye in September 1999 with as striking a cover as I'd ever seen; a man dressed as Ronald McDonald pointing at a stylish logo for a publication I'd never heard of. Inside were pages and pages – hundreds of them – devoted to all things McDonald, stunning photography of happy burger eaters in airports and malls, short stories, quirky facts and weird snippets, games, quizzes, architecture… all placed in a design context that was innovative and original enough to be totally compelling. Both elements, the content and presentation, were individually stunning, but together they presented an outstanding editorial project.

At the time I was working at wallpaper* magazine. Back from lunch clutching the McDonald's issue of Tokion, I saw the creative director of the western style bible reading the same issue, giving off those unmistakable signs of envy and admiration. That was when I knew my first instincts about the originality and professionalism of Tokion had proved right. Which is really strange because at the time Tokion didn't even have an art director – and at the time of writing still doesn't, though editor-in-chief and creative director Lucas Badtke-Berkow is on the hunt for one.

The 30-year old Baltimore-born Badtke-Berkow graduated from college in American Studies, though he says he'd been "making magazines and working for newspapers since seventh grade. I came to Japan the day after I graduated with the idea of publishing a magazine and met a guy named Adam Glickman in my Japanese class. We became good friends and I asked him to do the magazine with me. He said okay and the rest is history," recalls Badtke-Berkow. Six years on Tokion's independence is now assured, though it's been joined by a growing number of KHM ventures; a website (TokiONline), a TV show (Tokion Town), and a new kids' magazine called Mammoth. All are conceived and produced by Knee High Media Japan (KHM), which is wholly owned by Badtke-Berkow. And along with that, Tokion and Badtke-Berkow produce a growing range of merchandising related to the magazine, all of it having to reflect and match the high production and design ethos of the magazine itself.

Tokion ("the name is 'sound of now', so we've always got our ears to the wind," says Badtke-Berkow) was conceived as a publication whose "editorial policy is to do things that we like, because we like them. We wanted to be an example of what a magazine should be," he adds. "It mixes people and disciplines in a blender and produces the perfect cocktail. Tokion is like a good DJ. It selects, plays and shows things on time, in real time. It's filled with inspiration both for the people making it and those looking at it. It's friendly and non-pretentious."

"It's also the first magazine to be made in Japan and distributed to a world market which really respects it," adds Badtke-Berkow. Tokion's circulation is global, he says, and after publishing in Japan the magazine is reprinted in America and Hong Kong, switching all the advertising to fit the specific market. "So the editorial is the same, but the advertising and printing is different, because our readers are in their 20s and 30s, run a gamut of styles and have an infinite number of interests," explains Badtke-Berkow.

As creative director with no art director and a growing number of other projects to oversee, it's obvious that Badtke-Berkow currently has a lot on his plate. How does he cope? "I've got lots of friends and a great staff that give me ideas and advice all the time. Also Tokion has really good graphic designers who, once they have a grasp of the editorial and concept for a piece, are able to come up with some good ideas as to how to present the articles and themes." He is keen to welcome a new art director, and it will be interesting to compare the work seen on the following pages, taken from Tokion issues spanning the years 1996 to early 2000, with newer issues to see how – or if – Badtke-Berkow's vision and originality is interpreted and affected by another creative.

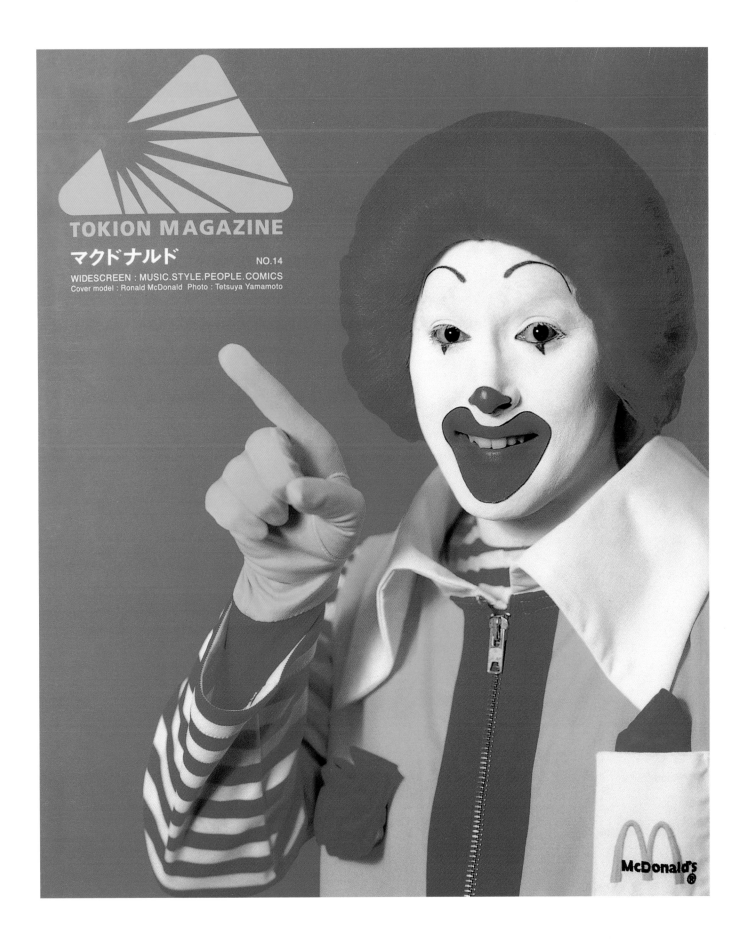

TOKION MAGAZINE
マクドナルド NO.14
WIDESCREEN : MUSIC.STYLE.PEOPLE.COMICS
Cover model : Ronald McDonald Photo : Tetsuya Yamamoto

McDonald's®

0.1 logo ↙ ↘

Tokion's editor-in-chief and creative director Lucas Badtke-Berkow devised the prism logo for the first issue of Tokion in 1996. "It ties in with the fact that we do theme issues. The idea is that the theme is the sun and the people that make the magazine interpret that theme in different ways, filtering it out into new lights, thus the prism," he explains. "We also keep to the slogan 'Widescreen' (originally a word used by Sony for its TV's shape). Widescreen to us is a way of thinking – openly, honestly and happily."

0.2 keyword ↓

"Themes, such as this issue around 'Friendship' from 1999, keep the magazine fresh and give us a keyword to start from. Depending on that keyword, ideas and approaches are changed," says Badtke-Berkow.

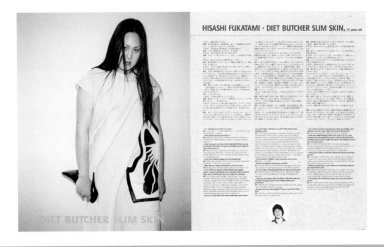

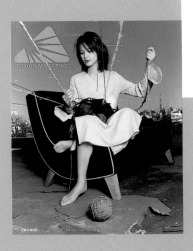

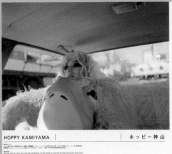

0.3 grid ↓ ↑

Tokion's lack of an art director determined its evolution as a project which doesn't have an underlying grid or rigid body font use, as these spreads from the 1998 'Sound' issue illustrate. "The idea up to now was to match the design and content with the original idea for the story. That's why each issue and each story look so different," says Badtke-Berkow.

0.4 format

The departure from the idea of a set style carrying through the individual issues – as illustrated by these three 'Smoke' section pages from different issues – is coming to an end, says Badtke-Berkow: "We want to try and format the magazine a bit more, because we want it to be easier to understand for more people. Up to now Tokion has been not just a look but an attitude and a feeling – we've now accomplished expressing that attitude and feeling, and we've come to understand it a bit more so the next step is to interpret that visually. However, we'll still keep our original edge, because that's one of the things that sets us apart."

0.5 japanese fonts

Where the use of Roman alphabet fonts is extremely varied for both display and body copy, the Japanese fonts are a lot less so. "It's very hard to work with. It's not the prettiest looking of languages and it's very complicated and hard to experiment with typefaces, both because of the enormous size of the language and because of the shape of the characters," explains Badtke-Berkow. However, he adds that while "the two languages are very different, all things that are good can be understood on a global and simple level, so when choosing stories, content and design we are always thinking locally and acting globally."

0.6 graphic devices ↙ ↑

Badtke-Berkow says he plans each issue "one day at a time. I'm influenced by everything and everybody around me, and when my heart says 'this is right', then it's usually right." He and his staff incorporate all the graphic devices at their disposal as page furniture, including graffiti, sketching, art and an imaginative use of fonts.

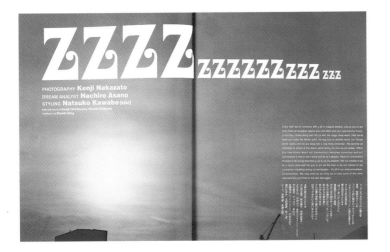

0.7 pull quotes ↑

Most of the features in Tokion eschew pull quotes and standfirsts because, says Badtke-Berkow, "we like to lay low and let our work stand out without having to punch and pull people into it."

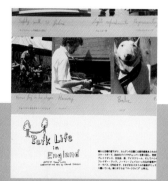

CONTENTS

目次

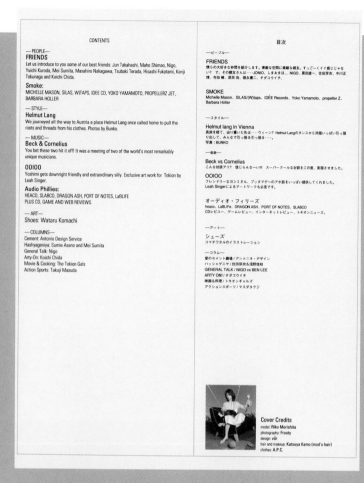

Cover Credits
model: Riko Morishita
photography: Frosty
design: vår
hair and makeup: Katsuya Kamo (mod's hair)
clothes: A.P.C.

0.8 contents page

The contents page is the only regular section of the magazine that retains a fairly rigid style; very clean and clear, with just one small reproduction of the cover as imagery, because, says Badtke-Berkow, "it's the contents and it's important that people know what's in the magazine. We don't want to confuse them." The lack of page numbers may seem like a design conceit but is in fact purely functional: "It makes it easier for us to do changes to the American and Hong Kong reprints, where the editorial is the same but ads change and page order changes."

0.9 commissioning

While Badtke-Berkow keeps a tight rein on each issue, he welcomes commissioning, both intellectual and artistic, from friends and staff. For these spreads from the 1998 'On The Road' issue, each "written by different people interested in different things", he wanted to "express the feeling of being on the road, a simple diary, but still make it visually simple and also kind of like a road movie." To achieve that he commissioned illustrations by different people for each one.

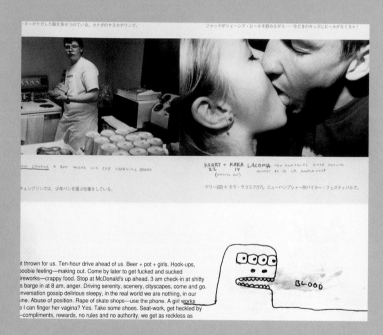

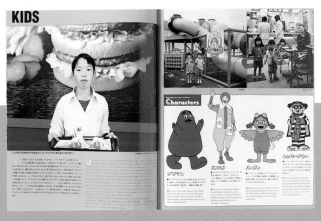

1.0 creative direction ↓

The extensive use of childhood images is indicative of Badtke-Berkow's confident and individualist creative direction. Where many youth lifestyle magazines would follow marketing rules and avoid images of children, he takes the bold step of including them because, as he simply puts; "I just like kids. In fact my next venture is a kids' magazine called Mammoth."

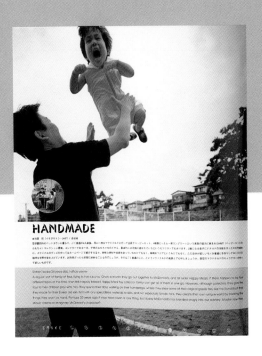

1.1 themes ↓ ↑

This 1999 issue of Tokion is a good example of the way each issue is creatively developed and themed. "As the issues usually revolve around things that are close and personal to us, this was a great one to do. I eat at McDonald's approximately four times a week and I like their pop and global image. It's an icon that is understood around the world. We collaborated with McDonald's under the conditions that they let us do what we wanted to do. They were very helpful and everyone – the readers, McDonald's and us – was all happy with the final product."

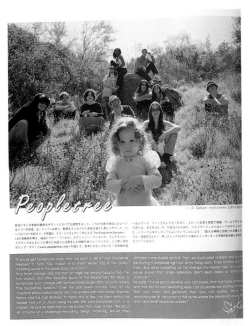

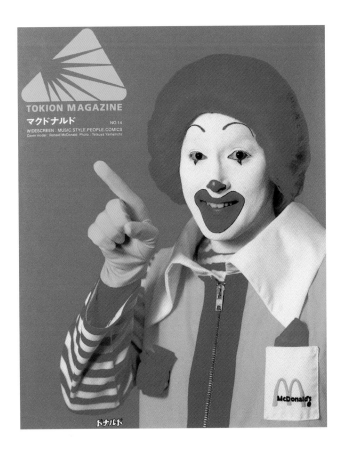

1.2 brand identity ↓ ↗

Merchandising plays a strong role in the brand identity and recognition of Tokion, which sells things like this clothing and stationery bearing the Prism symbol. Badtke-Berkow ensures the brand standard is carried across to these offshoots through close collaboration with the producers: "Most of the collaborations are done with friends so it's easy to work together, and we make production sourcing and quality control a priority," he says.

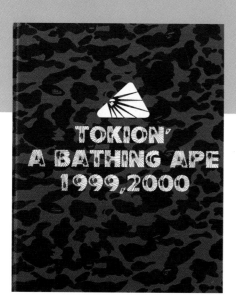

1.3 give-aways ↓

Offshoot publishing projects and pullouts are often given away with Tokion, such as Soy Source, described by Badtke-Berkow as "a two part book/kit on Japanese hip hop. We wanted to make it like a kind of school book or learning aid, but keep it real fun. The Soy Source gives an eastern slant to the hip hop magazine Source."

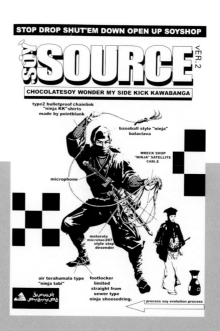

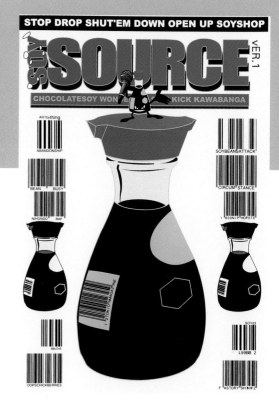

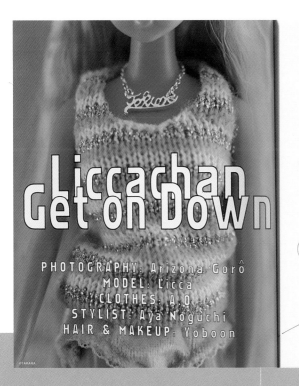

Liccachan Get on Down

PHOTOGRAPHY: Arizona Gorô
MODEL: Licca
CLOTHES: A.O
STYLIST: Aya Noguchi
HAIR & MAKEUP: Yoboon

©TAKARA

Yellow velour panty and yellow and silver boarder knit vest by **A.O** and silver **TOKION** necklace by **A.O**

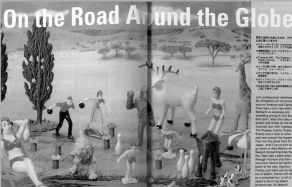

On the Road Around the Globe

1.4 comic book art ← ↖ ↗

The playfulness of Japanese youth and the fanaticism around comic book art is well interpreted in all sections of Tokion, which will often use toys, cartoons and childlike imagery and themes as visuals for everything from the fashion spreads to advertising and cookery pages.

1.5 themes

For the first issue of 2000, Badtke-Berkow decided to publish a themed issue around 'New', a large part of which was given over to new talent in the creative arts. "Once we've got a theme, we think of stories for the theme, then about photographers that would be appropriate or add an interesting slant or compliment the original idea."

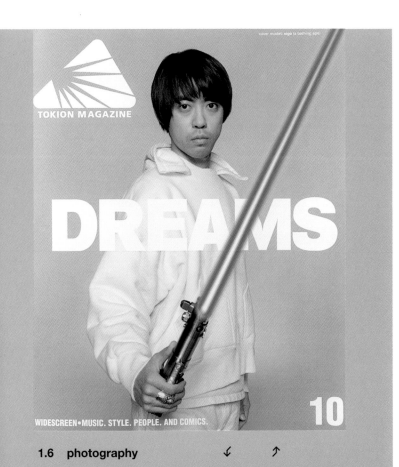

1.6 photography ↙ ↗

Badtke-Berkow says the actual process of a shoot is very straightforward: "Ninety-five per cent of the photography, illustrations and art we use we commission... or rather ask our friends to participate in a concept. Once we decide on a photographer we sit down with them and talk about the story – the photographer will usually come up with interesting things that we didn't think about – then we mix and match all these aspects together and proceed with the shoot. However, after the shoot we usually involve the photographer in the selection and graphic design stages as well. So the end product is something that everybody made together and can be happy with."

1.7 production ↑ ↙

Over the five years since its inception Tokion has seen a radical shift in design and production, following an evolutionary path from rough and ready two-colour matt pulp oversized indie to the much slicker, glossier four colour brand-heavy publication it now is.

To a large degree, the look of each issue is determined by its content, and Badtke-Berkow insists on original thought and creation for both: "Everything we do we make specifically for the magazine; we try to get creators to create things specifically for it and not use photos and graphics that are already in circulation." He credits technology as adding little to the creative mix, instead choosing to wait and be "hit by idea lightening bolts".

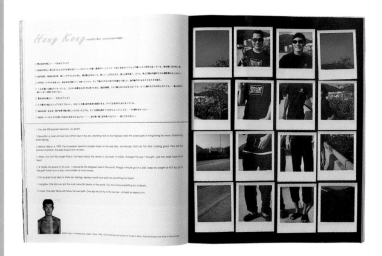

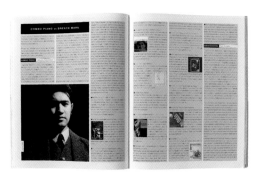

Jerry Ukai, Tokion's designer

comments

project credits

Editor-in-Chief and Creative Director Lucas Badtke-Berkow

Design Director and Design Miyuki Hentona

Tokion

Knee High Media Japan

101 Wood House, 1–11–3 Higashi

Shibuya-ku

Tokyo 150–0011

Japan

T +81 3 5469 9318

F +81 3 5469 5656

E-mail tokion@ari.bekkoame.ne.jp

www.tokion.com

Jerry Ukai, designer

The role of designer on Tokion falls to two people, Jerry Ukai and Toyama San. Both are instrumental in visualising and interpreting the editorial concepts and directions spearheaded by creative director Lucas Badtke-Berkow, and both are given the leeway to develop and explore their ideas fully. As Ukai explains, that is achieved first and foremost by "working as part of a team; we all work very closely together, hanging out and talking and creating a space where we are all feeling the same way. We put our souls and hearts together. Then we're given complete autonomy in designing pages for the magazine."

Trying to pin down Ukai on the production process and creative development of the magazine proves difficult: "Each issue bounces about like an atom on the loose. It changes over and over and then when it's just right it goes to the printer," he says spiritedly but enigmatically. He's equally enthusiastic about the merchandising and spin-off material around Tokion; the clothing, stationery, comic books and specials are all things Ukai has a hand in designing and developing, saying it's one of the best things about working on the magazine. And one of the worst? "It's not a bad thing, but the thing I'm most worried about is making my design appeal to a young crowd. We have very many young fans and I'm really happy about that, but I want my design to remain fresh."

project 0.4 wallpaper*

wallpaper* magazine, launched in 1996 at the tail end of a boom in magazine publication which had seen the emergence of lad mags and gadget mags and a surge in gardening and interiors titles, became something of a publishing phenomenon within six months of its launch. The brainchild of its then and current editorial director Tyler Brûlé, the magazine was quickly recognised for its ground-breaking potential by the multimedia giant Time-Inc., which bought it in 1997. Unlike its recent predecessors, wallpaper* (the asterisk refers to the sidenote 'the stuff that surrounds us' on the cover but has since become a distinctive and integral part of the magazine's masthead) eschewed the whole celebrity/profile/gossip/puff pieces, bravely choosing instead to celebrate contemporary living by showcasing design in its widest sense. The magazine's design mirrors the visual strength of its subject, using stunning photography, re-energising the art of illustration and creating a modernist style that endures, and has the figures to prove it; it sells in over 40 countries, its ABC figures for July–December 1999 stood at 125,984, a 23 per cent on-year growth, and it has gone from bi-monthly to publishing 10 issues a year; seven 'classic' issues, two Wanderlust issues dedicated to international themes and travel, and the wallpaper* 100 annual.

The wallpaper* reader profile is described by Steve Teruggi, wallpaper*'s on-line editor, as "sophisticated, well-travelled, brand-savvy, city dwelling men and women." Teruggi attributes the magazine's success to it being "a highly edited catalogue of great design. It's recognised as the first magazine to talk to a new generation of urban modernists and global navigators, and has broken most of the rules that govern glossy publishing." Teruggi's brazen statement is undoubtedly true; regardless of whether you love or loathe the ultimately acquisitive and aspirational nature of wallpaper*, you have to applaud the way its originality has been a kick in the teeth for the narrow confines of most corporate publishing.

Where off-line publishing success goes on-line ventures are sure to follow, so it was just a matter of time before the idea of a wallpaper* website was raised. But how to translate the print version, with its big bold images and emphasis on the visual, to the on-line world, a world notably bereft of big bold images and whose emphasis is arguably not on the visual? The pitch for its design was put out for tender in spring 1999, and in September 1999 it was revealed that the job had gone to internationally renowned multimedia and advertising group I-D Media Gruppe, "chosen because of their grasp of design and technology and their forward-thinking attitude," said wallpaper*'s editorial director Tyler Brûlé at the time.

Established a decade earlier, I-D Media had a wealth of on-line design experience, including a website for Swatch, for which it won a coveted US gold Clio award. The original pitch, against a number of international competitors including Razorfish and Icon Medialab, was made from its Hamburg office, but the design work was to become the first undertaken by the new London office, opened in the same month. Jonas Lyckstedt, designer, was part of the original team who made the pitch and later transferred to London. Carl Captieux, interactive production manager on the wallpaper* site says: "We understand the brand really well and as lead designer Jonas has a very good relationship with wallpaper*."

Ultimately a good relationship with wallpaper* means a good relationship with its editorial director, Tyler Brûlé, whose hands-on approach to every aspect of the magazine, and now the website, is one reason that both maintain their high standards in all areas of design, content and direction. Teruggi again: "Tyler is very closely involved with the website and insists on approving every piece of design and copy before it goes on-line. Obviously, he's very good at knowing what will work for the brand that he created and what will not." His attention to detail is already paying off; at time of writing, a few weeks before the site's launch, i.e. before any formal press releases or marketing, www.wallpaper.com registrations are placed at 23,197 and rising at 500+ per day.

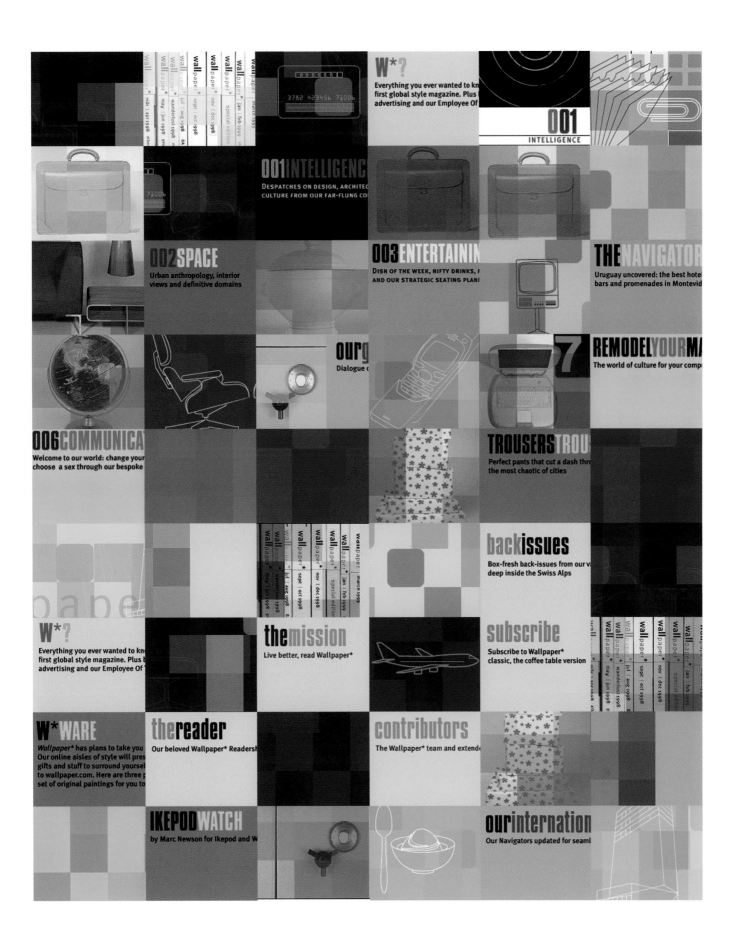

W*?
Everything you ever wanted to kn
first global style magazine. Plus
advertising and our Employee Of

001
INTELLIGENCE

001 INTELLIGENC
DESPATCHES ON DESIGN, ARCHITE
CULTURE FROM OUR FAR-FLUNG CO

002 SPACE
Urban anthropology, interior
views and definitive domains

003 ENTERTAININ
DISH OF THE WEEK, NIFTY DRINKS,
AND OUR STRATEGIC SEATING PLAN

THE NAVIGATOR
Uruguay uncovered: the best hotel
bars and promenades in Montevid

ourg
Dialogue

REMODEL YOUR M
The world of culture for your comp

006 COMMUNICA
Welcome to our world: change your
choose a sex through our bespoke

TROUSERS TROU
Perfect pants that cut a dash thro
the most chaotic of cities

back issues
Box-fresh back-issues from our v
deep inside the Swiss Alps

W*?
Everything you ever wanted to kn
first global style magazine. Plus b
advertising and our Employee Of

the mission
Live better, read Wallpaper*

subscribe
Subscribe to Wallpaper*
classic, the coffee table version

W* WARE
Wallpaper* has plans to take you
Our online aisles of style will pres
gifts and stuff to surround yoursel
to wallpaper.com. Here are three p
set of original paintings for you to

the reader
Our beloved Wallpaper* Readersh

contributors
The Wallpaper* team and extende

IKEPOD WATCH
by Marc Newson for Ikepod and W

our internation
Our Navigators updated for seaml

wallpaper*

launching soon

0.1 on-line trailer

Wallpaper*, an international magazine for international consumers, showcases the best of contemporary fashion, architecture, product and industrial design, signage, typography, art... this focus on the stylish, creative, and above all modern had to be hinted at in the the on-line trailer without giving too much away.

0.2 navigation ↑ ↓

"We did the first sketches based on a Wanderlust issue of wallpaper*. There was a small graphic device used to flag each section that inspired us to create the navigation palette," explains Jonas Lyckstedt, designer at I-D Media Gruppe. "The original idea hit the nail on the head," adds Carl Captieux, interactive production manager.

0.3 navigator city guide ↑

Website content is new, with no repurposing of content from the print version planned, however there is overlap in one area: "In the Navigator City Guides section, we felt that the Web gave us an opportunity to create a unique resource of information that was not possible in print, where obviously we can't add or remove items from the guides once the magazine's in print. On the site, from our archive of international city guides we are able to update and add to previous cities featured in the Navigator," explains Steve Teruggi, wallpaper*'s on-line editor.

0.4 e-commerce ↑ ↓ ↘

wallpaper*'s editorial choices have a great deal of power in driving sales of products, so the e-commerce side of the site is very important. Teruggi spent a long time getting everything from user experience to fulfillment exactly right: "We have cases of suppliers that feature in wallpaper*'s pages becoming flooded with orders as soon as they appear in the magazine," explains Teruggi. "It seemed silly not to take advantage of this, so a store section of the site was developed to offer selected products, most exclusive to us or hard-to-obtain without travelling to their city of origin. It is not about saving money or finding a bargain. It is about providing a valuable additional service to our readers."

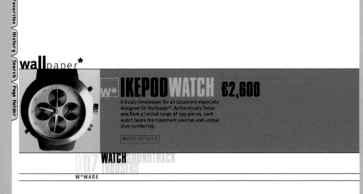

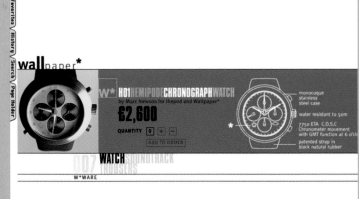

0.5 updates

Wallpaper* prides itself on leading the field in design and architecture news, but the long lead times of the print edition mean that there are often items that don't make it into print, simply through their breaking as news stories at the wrong time. "The immediacy of the internet allows us to take advantage of a lot of information that would otherwise be wasted. Main sections of the site will be developed and launched offset with the magazine publication dates. We have weekly updates with areas like 'Dish of the Week'. The aim is to have constant new offerings available," says Teruggi.

0.6 content

One of the the most difficult tasks any content provider faces going on-line is tailoring written copy and graphics to suit on-line. "The visitor to a website is not a captured audience in the same way that someone who has purchased a magazine is. There is much less control over how it is viewed, so you have to present it in a way that allows the user to follow their own interests. This gives us great scope to use images and text in a much more productive way, once the boundary of a printed page is removed. An idea is no longer restricted to what is seen by the eye on the given measurements of a page, but can grow and include sound, animation, video and so on," says I-D Media's Captieux.

TRAVEL

0.7 interactivity

A key aim of the wallpaper* site is to only use interactivity where it is needed and serves a definite purpose. "The use of every aspect of multimedia on every page of a website can end up diluting the impact of any content that you have," says Captieux. "If the content is strong, it can stand alone without being animated or added to in any way," agrees Teruggi. "Having said that, the nature of the internet allows us to interact with visitors to the site, which can be fun. We have tried to find a balance," he adds.

CONSULAR SERVICES

COMMUNICATION

0.8 graphic style

wallpaper*'s distinctive graphic style is beautifully reflected on the website. "wallpaper* provided a lot of art direction, and it was very useful to be able to refer to a library of past issues with them," says I-D Media designer Jonas Lyckstedt. "Having an existing visual language to communicate ideas in makes developing a site much easier than when you start with nothing."

03.30PM

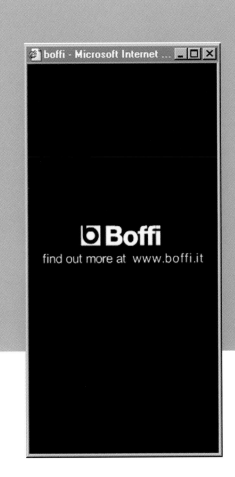

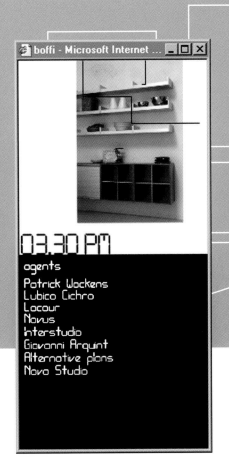

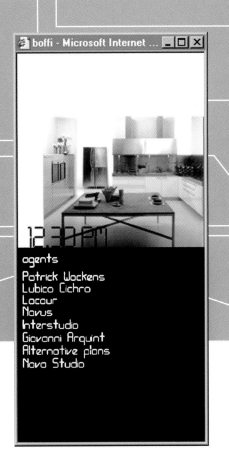

0.9 banner ads ↗

Where are the banner ads? There are none, instead the adverts have been blended into the main design and open as separate windows with animations. "The magazine has a keen policy for seamlessly integrating advertising and editorial. For example, we've placed the Boffi and SwissAir logos in the sub-navigation bars on the site. We came up with this idea as a way of including a valuable presentation for the advertisers that was also genuinely entertaining for the viewer rather than being an irritation or distraction for our content," says Teruggi.

12.30PM

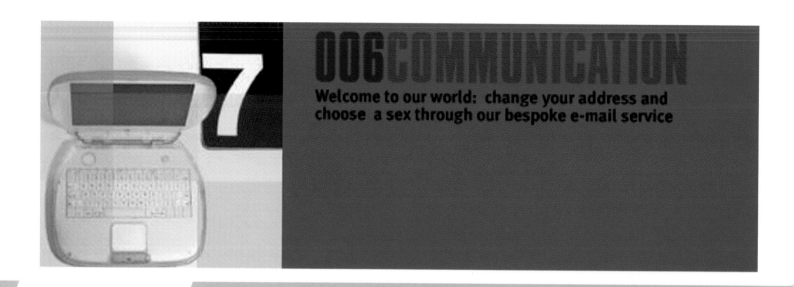

006COMMUNICATION
Welcome to our world: change your address and choose a sex through our bespoke e-mail service

1.0 download times

Despite the heavy graphical content the site avoids all the traditional problems of long download times. There is a strong use of interactivity in the navigation and display. The square nine-sectioned navigation palette allows the user to select a section they want to explore which then opens horizontally to display its content and offer subdivisions. Almost all of this relies on the use of Flash4. "Flash and the ability to embed fonts is why the site is able to look like wallpaper*. We rely on scripting in Flash and Java for the success of the back end of the site. The user might never notice it, but for the site to feel like a slick, sophisticated experience it is important that these technologies are utilised in an appropriate way," says Jonas Lyckstedt.

1.1 flash

The site uses Flash, Generator and Freehand. "We chose Flash because it's very flat, very clean and also it streams very well and you don't have to download the whole thing first. It's really important for the user that they see something straight away. You can load small movies in 40k chunks and then you load another movie behind that. Also Flash is scalable and you can use any colours with Flash without being restricted to the Web-safe colours and you are not restricted in the choice of fonts," says Carl Captieux.

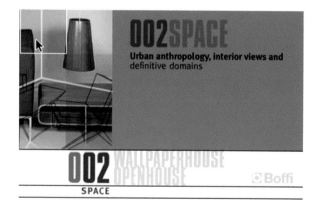

002SPACE
Urban anthropology, interior views and definitive domains

002 WALLPAPERHOUSE OPENHOUSE ◻ Boffi

SPACE

009 ARCHIVE LOADING ☐☐☐

1.2 future

"We see the site as a starting point for a lot of ideas and projects that we hope to develop in future. The magazine and website should always work together, as there are certain story ideas that are better suited to the magazine, and some which we can do more with on the website. Even for the store, it is the items that we source via our magazine editors and correspondents that get put on sale. Every aspect of the site is integrated into the magazine so that we can build up a unique relationship between a publication and its readers/viewers," concludes Teruggi.

Steve Teruggi, wallpaper*'s

comments

project credits

I-D Media Gruppe

Berlin (Headquarters)

Lindenstrasse 20–25

10969 Berlin Kreuzberg

T +49 (0)30 25947 0
F +49 (0)30 25947 111

E-mail contact@i-dmedia.com

London

I-D Media London

Zetland House

Unit E

5/25 Scrutton Street

London EC2A 4HJ

UK

T +44 (0)20 7749 5400
F +44 (0)20 7749 5401

E-mail london@i-dmedia.com

www.i-dmedia.com

on-line editor

Steve Teruggi, on-line editor

Nestled between wallpaper* editorial director Tyler Brûlé and the designers at I-D Media, what exactly does the position of on-line editor entail? "I advise on how the website can take advantage of available technology, and explore the content and ideas that we have in the best possible way, as well as dealing with commissioning content and day-to-day running of the website. It is important to wallpaper* that the website speaks with the same style and tone as the magazine, so it is the same writers, editors, photographers and illustrators that are involved in the site as are in the magazine. We wanted to ensure the same production quality that is seen in the magazine also features on the website, as that is one of the key elements missing from the internet – consistent quality. Over the past two years there's been growing interest in the idea of a website; requests from our readers, together with suggestions from the current staff that a website could be beneficial to the brand and obviously to our readership."

"The development of a website was under consideration for a long time for two reasons: firstly, wallpaper* wanted to ensure that any venture on-line was as ground breaking and innovative as its productions in print. Anything that was done had to be different from anything else that existed. And secondly, wallpaper* was not interested in going on-line in the kind of blind panic and bandwagon-hopping fashion that has been the reaction of so many companies over recent years. It has an excellent reputation internationally, and it was seen as essential that when a site was launched it lived up to the expectations of our audience. Essentially, wallpaper* could thrive and continue its success without a website. We feel, however, that the ideas that we have, and with current market trends, an on-line presence is something that we can use as both a brand extending venture and a money making one. If you compare the demographic of the magazine with the average user of the Web, it would seem that our audience is already wired and Web savvy. Given that fact, we certainly hope that we extend our following through our website. Similarly we hope that our site attracts a new audience which might not be interested in the magazine, but get hooked through the website."

project 0.5 nest

As more people become more knowledgeable, interested and active in interior design than ever before, the rise in magazines to serve them has been huge. The scope and range of these reflects every aspect of interior design, from the basic DIY magazines which suggest '50 ways to transform your bathroom' to the more esoteric and style-conscious titles that illustrate the incredible creativity that can be achieved by pushing boundaries and going beyond the accepted norm and rules.

In this latter camp lies Nest, a quarterly American 'shelter' magazine now in its third year. In just ten issues Nest has won design awards around the world, including, in 1999, five Ozzies for: magazine design excellence; best overall design for a new magazine; best cover; best use of photography; and best feature design. And earlier this year it won the 2000 National Magazine Award for General Excellence (under 100,000 circulation).

The plaudits are well deserved, for Nest has gained a fanatic following (and a circulation of 75,000) for what it calls "London and Paris interiors meet igloos and prison cells on equal terms." Its first issue contained features on Cold War Barbie's Dream House, a visit to the home of famed Parisienne decorator Jacques Grange, a 1920s' alpine garden recreated in Washington State and a tour of artists Gilbert and George's east London home. All of it was bound into a cover that editor-in-chief and art director Joseph Holtzman recalls being told would never sell, featuring as it did hundreds of magazine covers which decorate the suburban home of Raymond Donahue, a fan of Charlie's Angels actress Farrah Fawcett. It's incredibly bold in its predominantly black-and-white cover shots of Farrah, punctuated by spots of colour such as a colour TV screen image of the actress, and it sold phenomenally well, putting the lie to the warnings Holtzman received when designing it: "I really liked the idea of a cover made up of a collage of other magazines, but people said 'you can't put other magazines on the cover, it's subliminally advertising them and nobody does it', but I liked it and still do."

Holtzman set up the independent magazine with absolutely no experience of magazine production, something he sees as a bonus: "If I had known anything about it I probably wouldn't have done it – I was propelled by ignorance." He had been working with the British architect and photographer Derry Moore (now London editor of the magazine) who suggested doing a magazine where "those who look and those who read meet on equal terms, a publication that would use award-winning photographers and writers to bring special energy and perception to the features," says Holtzman. "I didn't want to tell anyone about it as I knew they'd try to discourage me," he adds. From the beginning he envisaged a product that would give his readers something they wanted to keep: "I wasn't interested in producing a disposable object targeting a particular profile," he says. Indeed, when raising the funds for the magazine, he continues, "the men in grey suits kept asking 'who's your reader?' and I'd answer 'whoever reads it'." That comment underlines Holtzman's extraordinary boldness; he meant "whoever wants to", but his choice of words could also be taken to mean that whoever read it would become a reader of the magazine – a subtle but important difference.

Three years on Holtzman is still reluctant to profile the Nest reader beyond "being someone who is smart and not even necessarily interested in design, as our literature is very strong. I'm lucky enough to work with a literary editor, Matthew Stadler, who is as obsessed with words as I am with lampshades. He brings ideas to the magazine and I determine how we present them and what twist to give them," he says.

While the writing is exceptional, it is Nest's visual content and design that initially strike the reader, and this is very much down to Holtzman, graphics director Tom Beckham ("a prosthesis who reads my mind" says Holtzman, but also a graphic designer and professional jazz musician!), and production manager Della R Mancuso. A printer in Italy realises their vision and hard work in a process that would make most magazine editors blanche. Holtzman thrives on it: "I could never sell Nest, I want to stay fresh and keep doing it," he says. It will be interesting to see how Holtzman pursues this aim; especially given a range of covers that have so far included flock wallpaper, gold glitter, die-cast cut outs, hole-punched card and Todd Oldham commissioned fabric. Let's just hope his determination to stay fresh never wanes, though his refusal to look at other magazines should ensure Nest's originality: "I don't want to be intimidated by other magazines so I only glance through them at the hairdressers," he says carefully. Then modestly adds: "Though I understand that we're beginning to influence others."

WINTER 1998-1999

n

e

s

T

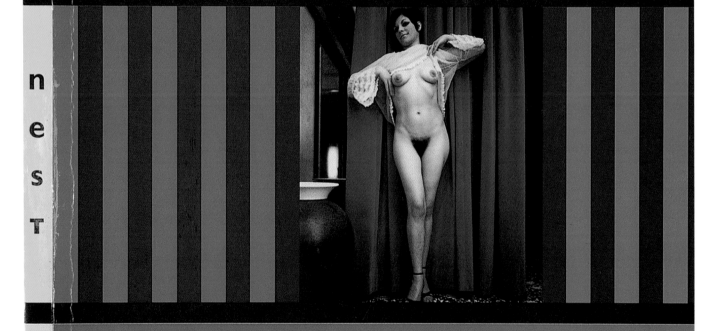

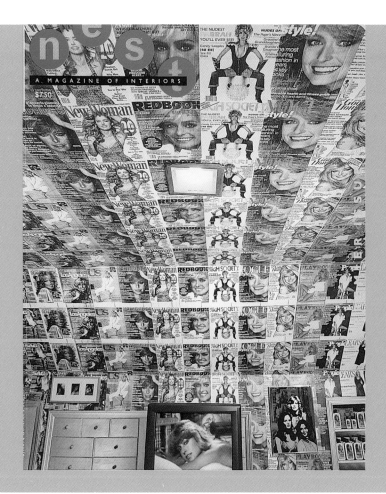

0.1 confidence

The first issue of Nest, shot by Jason Schmidt, featured the 'total Farrah environment' of Raymond Donahue, a lifelong Farrah Fawcett fan, but Joseph Holtzman, Nest editor-in-chief and creative director, says it's not just about the extraordinary: "I'm not interested in eccentrics for their own sake, so someone sticking chewing gum on their wall simply to create a new surface is not something that would interest me. There has to be beauty there, and I think there was here. Graphically though there are concepts in this issue that weren't that well-developed; it's a question of confidence, and as time goes by I've become more confident about making decisions and consequently the magazine just gets better and better," he says. Three years on, the summer 2000 cover was shot in an environment custom-designed for Nest, in which two gorgeous young things modelled Todd Oldham designed scratch-off underwear. Photography was by Nathaniel Goldberg.

0.3 materials

For this provocative cover, which came in 15 different colourways, Holtzman commissioned fashion designer Todd Oldham to design a fabric which wrapped around the whole magazine. Inside it was a feature that showed the Brooklyn Museum's art deco Worgeltz study clad in the fabric.

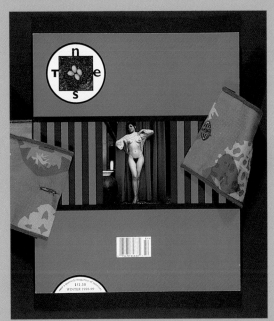

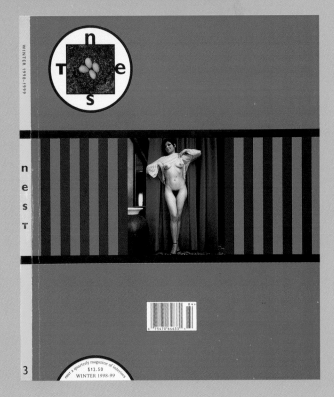

0.2 production

The Fall 1998 cover of Nest set the tone for many of the covers that have followed. Holtzman commissioned German artist Rosemarie Trockel to design a piece of flock wallpaper for this cover, which was production managed by Della R Mancuso: "I worked very closely with a UK wallpaper manufacturer to achieve Rosemarie's design, which had to be such that it would fit squares for the cover; we discussed the substrates we needed then sent them the artwork, which they worked up into proofs and samples. From there it was an extraordinary challenge to actually get the thing produced by our printers in Italy, who had to do loads of tests to find the right glues and cutting machines," she recalls.

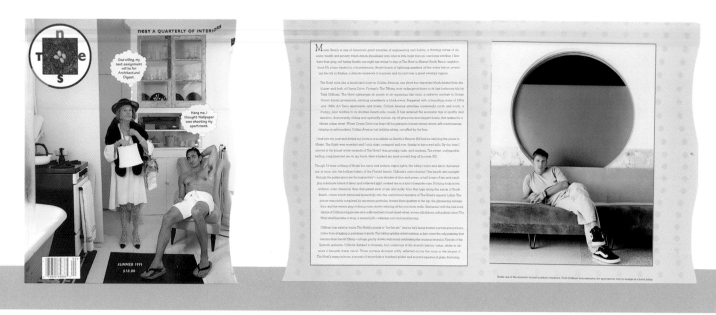

0.4 playful ↙ ↑ ↗

The summer 1999 issue was a particularly playful one, as the die-cut cover shows. Once inside the colours, borders and patterns were all themed around the colours, style and feel of Miami, centred around a feature (with photography by Todd Eberle) on Todd Oldham's first foray into interior design at The Hotel on South Beach.

0.5 invention ↙

For this feature about an original 1956 Philip Johnson glass house being clad in mock tudor and stone detailing, Nest was refused permission to shoot the house by its current owners. It got round the problem by showing a black-and-white picture of the original house overlaid with a sheet of clear acetate, on to which was printed a computer generated representation of the house as it looks now.

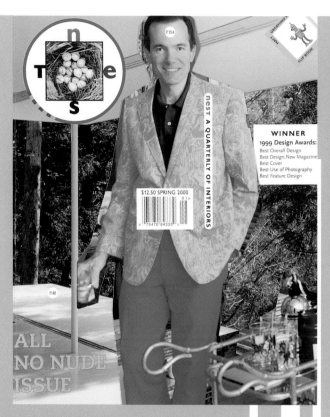

0.6 process ↑ ↗

The die-cut cover for the Spring 2000 issue was another production problem for Mancuso: "Joe showed me what he wanted, he and Tom made a prototype then I worked with the printer in Italy to create something that would match it. We came up with a die-cut graphic that could be machine-cut. A lot of what I do is about asking the printer to work with me to find a solution to a problem, it's just a process of back and forth – and patience!"

0.7 futurama ↓

Nest has a finely tuned sense of humour, as illustrated by this feature about brotherly love in ancient Egypt. The little black-and-white Bender characters from Matt Groening's 'Futurama' form part of a flip book running through the issue, to coincide with a Groening exclusive for Nest, the Futurama space tower.

WE'RE RATHER CLOSE final nest

TEXT CARL SKOGGARD
ARCHAEOLOGICAL PHOTOGRAPHS and EXPERTISE GREG REEDER

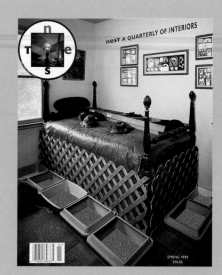

SPRING 1999
$10.00

0.8 contributor pages ↑ ↓ ↘

"The contribs pages are always a free-for-all done last, when the feel and concept of the issue has been designed. They incorporate a strong emphasis on what is to follow in the magazine – but not by copying, only enhancing. Joe usually requests a new contributor photo from each contributor, even if we already have their pic on file, allowing a more personal development. We adorn these pics in a number of ways; usually by applying the theme or subtext of the issue to each contributor," explains graphics director Tom Beckham. In these examples, that included adding rabbits' ears to each contrib and setting them in a logoshape (in this case the Bounty kitchen towel logo). "Most other front matter incorporates this technique," he adds, as the contents page shows.

0.9 experimenting ↗

This Langdon Clay cover, featuring just a few of Kristin Kierig's 114 rescued cats, uses real gold glitter in the litter trays. Mancuso experimented with a number of options and "spoke to loads of people" in the US before deciding that the best way to do it was to ship containers of US-manufactured gold glitter to Italy where the printer glued it on to the cover stock. The resulting image is almost three dimensional, with the glitter adding a convincing depth and warm texture to the cover.

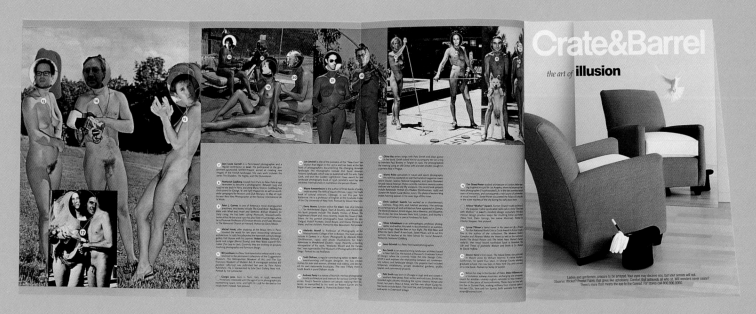

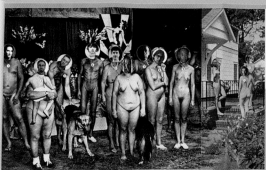

1.0 overview ↗

For a spread such as this one, Beckham will "FPO everything, derive backgrounds from Joe's research, create computer images, collect the art and provide sizing info to the printer, do Photoshop compositing, collect for output and send to printer, review chromalins, look for days off... etc. Obviously if there was text on the page, somewhere in there would be select preliminary typefaces and titling styles (up for change of course), and enter any text corrections," he explains.

1.1 representation ↙ ↓

This story about Aiden Shaw, an ex-prostitute and porn star who came close to death and is now a poet and writer, was designed to illustrate "the dichotomy of this sweet and childlike person with very adult experiences; so the rabbit 'wallpaper' represents that mix; childlike rabbits doing very adult things!" explains Holtzman. Coupled with children's storybook-style-type and layout, and Johnny Shand Kydd's photos of Shaw's South Kensington housing association flat, the feature presents a benign schizophrenia that beautifully expresses Shaw's dual-life experiences.

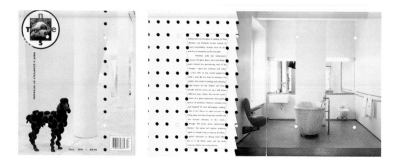

1.2 punching ↗

For this Fall 1999 issue, Holtzman put his three-year-old poodle Guido on the cover and let the dog's polka dot haircut by Yuri Okubo dictate the look of the entire magazine, beginning with holes punched through the entire issue. The contributors each had scanned illustrated poodle haircuts and many of the features used the motif, including this feature about a writer and photographer's stay at the guest quarters of Vienna's MAK museum, with photography by Matthias Herrmann.

1.4 autonomy ↓

"I like to give photographers and writers lots of license, secure in the knowledge that the writing is always rooted in the decorative arts. As long as the photos document the space with a sense of existing light then I treat them with respect. I occasionally go on shoots with the photographers, but I rarely interfere and don't style the houses; if they needed styling I wouldn't shoot them," says Holtzman emphatically.

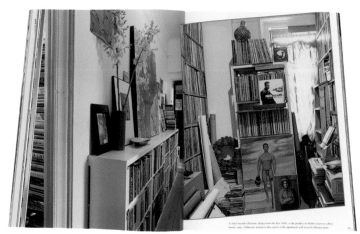

1.3 process ↙ ↘

In putting the magazine together, Beckham will "use Quark, Photoshop, Illustrator, Dreamweaver, etc... Because the files are scanned in Italy, I have to FPO most stuff and then keep it in a layer in Quark so that they can swap it. That's usually no problem except when Joe gets to putting borders on things (like all those contributors' pics), or when I need to have an Illustrator frame as a cut-out in a spread Photoshop file! The computer is integral to the process, but a lot of the images you see come from hard copy somewhere in the depths of the Holtzman library," he says.

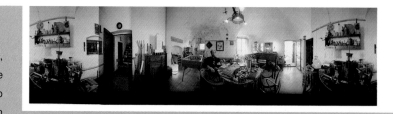

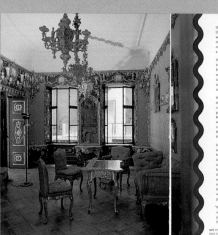

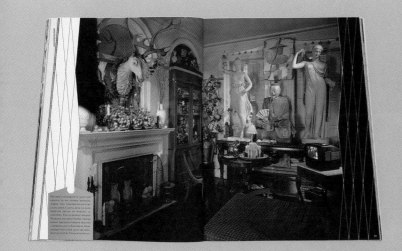

1.5 technology

"Because I'm more interested in decorative arts than fine arts, I frame the pictures carefully on the page," says Holtzman. He admits he doesn't even know how to use a computer: "Maybe that's an advantage. There's a danger with pages becoming sloppy as the bells and whistles overwhelm the designer; but my pages aren't sloppy, just busy," he adds. Beckham agrees: "In a way Joe would be less effective if he knew the computer programs. As it is we work together really well and on every story. Joe tells me where to put the pictures, how big to make them, what colour – everything. We have been doing this for so long now that I can anticipate a lot of things he wants to do, and he does respond to my suggestions and reactions, but I don't try to second guess him – there would be too much backtracking if I got it wrong!"

1.6 vision

"Nest is a highly individual magazine – with a highly individual publisher. It aspires to a level that is beyond the status quo, or whatever your idea of the status quo actually is. It's inspiring to complete the magazine on a technical level, to see it actually realised in physical form; a realisation of Joe's vision from the beginning," enthuses graphics director Tom Beckham. One example Tom particularly liked was this spread, which has Andrea Modica's image of an early 20th century male infant embryo printed as an 8x10 platinum/palladium print. Andrea discovered the bottle on a medical school shelf and writer Lisa Zeiger wrote a piece around it; together they made a fitting endpiece for the last Nest of 1999.

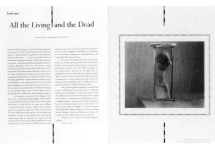

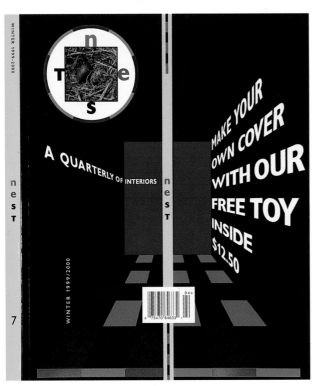

Della R Mancuso, Nest's

comments

project credits

Editor-in-Chief and Art Director Joseph Holtzman

Graphics Director Tom Beckham

Production Manager Della R Mancuso

Nest
www.nestmagazine.com

production manager

Della R Mancuso, production manager

Della Mancuso is responsible for setting, chasing and ensuring all deadlines on Nest, but she is also key in the relationship with the magazine's technical suppliers. Her background in producing books might not seem like the ideal one for producing a lavish quarterly magazine, but there's a lot of common ground, as she explains here.

"So much of what I do is about realising Joe's vision, and that involves close liaison with the repro house, suppliers and editorial staff, all of which I'm responsible for and all of which are not too dissimilar to my work in book publishing. A lot of the work in producing Nest is around working very closely with the printer, understanding and sorting out printing problems and technology, things I know about because of my book background. I have a really good relationship with our printers in Italy, who are responsible for all the colour separation and printing, and subcontract the binding, which they also do quality control on. In essence, they're completely responsible for the manufacture of the magazine, which is an eight-to-ten week process. We use them because Italian printers in general are experts in art book printing and custom work – for example, they can do smythe sewing, which is a type of high quality binding found only in Europe – and because of the dollar/lira exchange it's not prohibitively expensive."

"Creating a good relationship with a printer is about understanding the machinery and technical considerations, but it's also about merging the different mentalities and about everyone pushing to find new ways of doing things. Our printers have a hard time of it because they're coming at it from a manufacturing point of view, whereas we have a demanding artistic notion, the 'make it absolutely perfect' approach coupled with the 'and make it happen now' schedule of magazine publishing. But I work hard to make that schedule workable rather than punishing!"

"Having come from a book background where projects can last a long time and rarely deviate from the initial concept, what I love about working at Nest is the constant experimenting and the fact that we're so small, which has huge advantages in terms of making something happen, and happen fast. Because the whole concept of the magazine is more like a book than a magazine, in that it's not as formatted as something like Vogue, each issue throws up something completely new to deal with; ideas are constantly being scrapped or postponed and budgets necessarily shift with each issue, but it's always challenging and always changing."

project 0.6 dishy

On the face of it, a cookery book utilising flow charts, cheesy pics, snaps taken by amateurs and the chef's son, handwritten shopping lists and notes along with sumptuous photography, all combining to achieve a nice balance of the whimsical and stylish, is obvious. Yet Michael Nash Associates' design for the book Dishy by celebrated chef Kevin Gould stands out proudly from the crowd, screaming originality and wit that sets it apart from its contemporaries – and makes it an obvious choice for inclusion in this book. Dishy is a beautiful product to touch and hold, it has a luxurious tactile quality to it and unusually the spine and pages are cut at exactly the same size, squaring off the whole to give it a solidity that adds to its originality and boldness.

Design consultancy Michael Nash Associates' credentials for the job are obvious from its client list and background. Established 12 years ago by partners Anthony Michael and Stephanie Nash (hence Michael Nash – the combination of the surnames of these two founders), the company at first worked largely for the music business on projects for the likes of Björk, Seal, Massive Attack, Neneh Cherry and the Spice Girls. Work for fashion companies and designers including Issey Miyake, Jil Sander and Patrick Cox followed, then in 1993 the duo were commissioned to design the own-brand food packaging for London's most design-aware store, Harvey Nichols. The solutions they delivered were an early indicator of the tactile aspects of their work; these were packages you couldn't resist holding, touching, examining, feeling. They looked stunning and, unsurprisingly, won a D&AD Gold, an award that the company has added to with plaudits from the European Art Directors, New York Festivals, Germany's Design Zentrum and Chartered Society of Designers.

Michael Nash's current team of eight designers and two admin staff now deal with an ever diversifying client list which includes such prestigious names as The National Portrait Gallery, Space NK, Flos, Cassina, Louis Vuitton, Ian Schrager Hotels and, in publishing, Phaidon, 4th Estate and Hodder & Stoughton. It was Hodder & Stoughton which published Dishy, but the design commission came, unusually, through the author, not the publisher. David Hitner, senior designer on the project, explains the process: "We'd previously worked with Kevin on developing the visual identities for his grocery store, Realfood, his events catering company, Joy, and his café at Aveda in Marylebone High Street called Love Café. He didn't give us a formal brief, but we knew he wanted to create a book which was more than just a series of cookery tests with a picture of a celebrity chef's finished dish for you to compare with and feel inadequate." Equally unusual was the level of autonomy the designers and author had on the book, again down to Gould, says Hitner: "Kevin negotiated his publishing deal on the basis that he worked with us on the design of the book. Through working with Kevin on the previous projects we had developed a good understanding and respect for each others' specialities, and as a result of this Kevin trusted our design decisions." It was this trust that drove what Hitner describes as "a very informal working relationship with Kevin from the very early stages." Indeed, Michael Nash started working on the book before Kevin had even finalised the content. "We also met the publishers very early on, possibly a year before publication," adds Hitner. He and his team spent approximately one to two weeks working up the initial presentation boards and around two to three months of full-time work to create the book through to artwork. In doing so they've produced an editorial project that is exceptional in providing a new design direction and solution to what's traditionally been a rather stolid and predictable genre of publishing.

KEVIN GOULD

DISHY

0.1 food becomes you

From the outset, Michael Nash knew the mood and feel that author and chef Kevin Gould wanted them to interpret, an understanding based in part on their long working relationship with the chef, but also on his strong feelings about food and cooking: "He felt that the preparation and the eating of food is one of the most personal and social acts in our lives. One of the ways to thank or impress somebody is to cook for them, cooking makes you attractive or dishy, hence the title," explains senior designer on the project, David Hitner. Some of the other working titles along these lines were Shopping and Cooking (with reference to a play that was on at the time), Love Cooking and Food Becomes You.

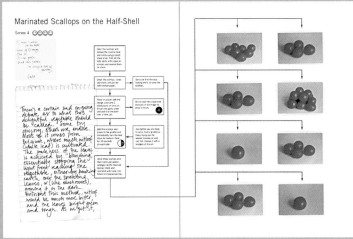

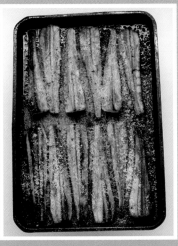

0.2 references

The design from the start was a bold departure from the normally accepted cookery book route of a perfect photo of the dish facing a clean page of ingredients and recipe in 14pt copy on 18pt leading. Hitner explains how that departure developed: "Kevin wanted to produce a non-elitist book focused towards a young audience. Jamie Oliver achieved this with his television programme, but when this translated into a book all his personality was lost, he ended up with a formula cook book with technically beautiful food photography mixed with black-and-white lifestyle shots. This could have been any celebrity chef's or restaurant's cookbook. So we wanted to make sure we got Kevin's personality across in the design of the book as well as through his text. Kevin's head is always full of ideas, he works at 100mph. To represent this we felt from the beginning that the book should have the appearance of a chef's sketch book with notes, stains from cooking and visual references to the source of each of the recipes."

0.3 contents

Michael Nash staff created a lot of the content with Gould. "With every recipe Kevin had included a story, a joke, a list... anything he felt gave that recipe a personality. We reacted to these visually, asking Kevin for additional material and creating our own," recalls Hitner. That visual reaction was taken further in chapter dividers and intro pages, for example an origami spread adds something different with a loose connection to birds for the poultry chapters, two cows in a comic strip format discuss cheeses... Graphic material used included tickets, packaging, diagrams, illustration, website pages, Love Hearts, air mail envelopes and even the stains cookery books inevitably acquire through constant use.

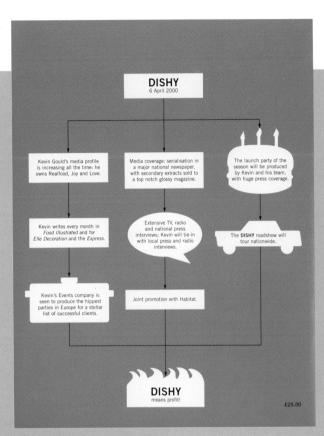

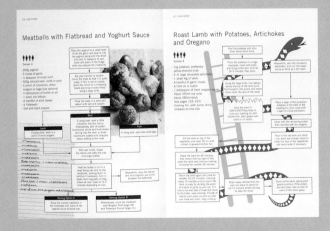

0.4 flow charts

The idea of laying out the recipes as flow charts was introduced with the initial presentation of the mood-boards. "We all liked it because within Kevin's recipes there is no right or wrong way to do things, at any point you could add an ingredient or be presented with a selection of ingredients to choose from which would then affect the direction and outcome of the finished dish," explains Hitner. The charts had a secondary purpose too, adds Hitner: "We felt that this less formal layout would possibly encourage the reader to experiment or tailor a recipe to suit their own tastes. The flow charts also allowed us to show where you could prepare in advance and then where these pre-prepared ingredients are reintroduced. Finally they helped give the book a unifying structure for us to work against." From seeing the initial idea boards Gould decided to restructure the way he described his recipes to fit in with the flow chart layout.

0.5 covers

From the outset, the designers took a number of different approaches to the cover material, reflecting the way Michael Nash generally begins work on a project. "Working in the music industry and with other retail clients we understand the importance of creating a strong visual message within a limited time-span and area, but that doesn't mean limiting ourselves to one direction at the initial stages of a project," says Hitner. With Dishy, he continues, "we worked on the different cover designs to see how they affected perception of the book and its content. Some were a direct response to the end retail environment. For example, the cling film-wrapped green beans and sandwich covers were a response to the possibility of the book being sold in a supermarket. We also proposed a cover in wipe-clean Formica, with a punched hole and butcher's hook so that you could hang it up with your pans in the kitchen."

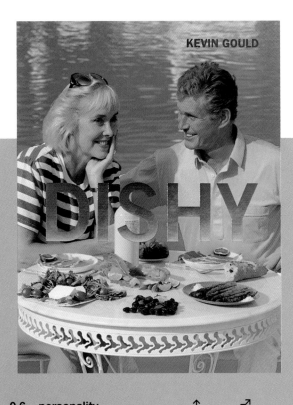

0.6 personality

The design Hitner and his team felt best summed up the personality of Gould's book was a stock image of a 'dishy' middle aged couple sitting by a swimming pool. "This was used for the blad after we photographed and retouched a selection of Kevin's food on to the image," says Hitner. Sadly the cover design was lost on various buyers for the major bookshop chains with comments like "too ironic", "too old" and "too urban", at which point the publishers got cold feet. "We tried re-cropping the image and changing the food on the table but their minds were set," says Hitner.

0.7 solutions

Once it was obvious that Hodder & Stoughton would not accept the couple on the cover, the publisher rebriefed the designers, asking for "a plain white cover with some reference to the flow charts inside," remembers Hitner. "From this we came up with the Kitchen Roll cover, chosen because it's an item that's common to all kitchens regardless of the ability of the cook. It also gave Hodder their white cover, added texture and a tactile quality and had a fun/less serious element in the illustration," he adds. It's also a great example of constraints being overcome without diluting the design's strength and cohesion; it's still quirky, characterful and striking. The inside cover (below) strengthens that sense of originality.

0.8 contents

The contents page in the blad was also changed, from a straight list to the cod till receipts that appear in the final book, as was the introduction page, which saw the male figure lose his trousers!

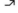

0.9 photography

Another strength of Dishy is its photography, which eschews perfect food shots in favour of a wealth of unusual imagery and many different styles, including shop fronts which were introduced as an element common to everyday life and "to illustrate that you do not need to go to specialist food shops to get good quality ingredients. The different feel of these images also helped us create visual breaks between the chapters," explains Hitner.

 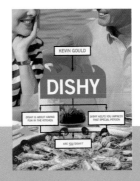 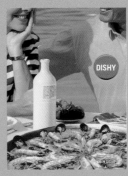

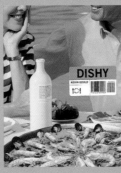

0.6 personality

The design Hitner and his team felt best summed up the personality of Gould's book was a stock image of a 'dishy' middle aged couple sitting by a swimming pool. "This was used for the blad after we photographed and retouched a selection of Kevin's food on to the image," says Hitner. Sadly the cover design was lost on various buyers for the major bookshop chains with comments like "too ironic", "too old" and "too urban", at which point the publishers got cold feet. "We tried re-cropping the image and changing the food on the table but their minds were set," says Hitner.

0.7 solutions

Once it was obvious that Hodder & Stoughton would not accept the couple on the cover, the publisher rebriefed the designers, asking for "a plain white cover with some reference to the flow charts inside," remembers Hitner. "From this we came up with the Kitchen Roll cover, chosen because it's an item that's common to all kitchens regardless of the ability of the cook. It also gave Hodder their white cover, added texture and a tactile quality and had a fun/less serious element in the illustration," he adds. It's also a great example of constraints being overcome without diluting the design's strength and cohesion; it's still quirky, characterful and striking. The inside cover (below) strengthens that sense of originality.

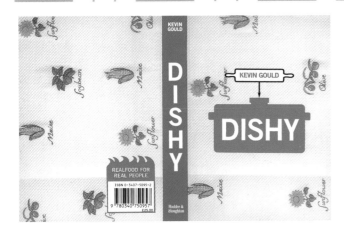

0.8 contents ↖ ↙

The contents page in the blad was also changed, from a straight list to the cod till receipts that appear in the final book, as was the introduction page, which saw the male figure lose his trousers!

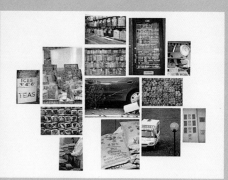

0.9 photography ↑ ↗

Another strength of Dishy is its photography, which eschews perfect food shots in favour of a wealth of unusual imagery and many different styles, including shop fronts which were introduced as an element common to everyday life and "to illustrate that you do not need to go to specialist food shops to get good quality ingredients. The different feel of these images also helped us create visual breaks between the chapters," explains Hitner.

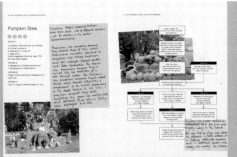
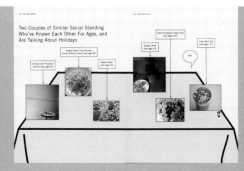

1.0 approach

Hitner wanted to break away from the photographic style of most cookery books and achieve an individual feel to the many photos in the book, so rather than take the standard route of two photographers – one for food and the other for lifestyle shots – "we decided to use a number of photographers, from professionals Annabel Elston (bath pictures) and Jason Lowe (dishy menus) to Rupert Cox (pumpkin stew) and Kevin's son Theo (peaches with prosecco), who between them provided a great mixture of commissioned shots and holiday snaps," he says. The final tally of credited photographers numbers twelve. The potential problems of such an unstructured approach in a medium that tends to be very structured – and therefore familiar to readers – was alleviated by the decision to break the food photography into three categories; conventional, unconventional and amateur.

1.1 text

Michael Nash uses the font Trade Gothic for all Gould's visual material, including Dishy, but the scrawled notes, post-its, postcards etc. which were incorporated into the recipes "to give the appearance of Kevin's own notes around his recipes" were handwritten by staff in the Michael Nash office. Through Photoshop it was easy to change their colour as necessary.

1.2 thumbnails

As pages were made up, thumbnail sketches were used to show the spreads in the way a magazine editor might quickly look at a flat plan to get a sense of the flow of pages. These thumbnails enabled instructions and changes to be easily and clearly marked up. Mac G3s with QuarkXPress, Photoshop and Freehand were used to produce the book; "nothing fancy", concludes Hitner.

Kevin Gould, chef & writer, Dishy

comments

project credits

Author Kevin Gould

Designers Michael Nash Associates

Art Director Anthony Michael

Designer Stephanie Nash

Senior Designer David Hitner

Designer Alexia Cox

Photographers Annabel Elston – alternative food images; Jason Lowe

Conventional food images Joanna Waller – divider images; Derek Hillier

Cover David Hitner – amateur food images; plus Alexia Cox from Michael Nash, Kevin and family, and a few more besides.

Illustrations Trevor Smith

Publisher Hodder & Stoughton

Project Manager at Hodder & Stoughton Laura Brockbank

Printer The Bath Press

Michael Nash Associates
42–44 Newman Street
London W1P 3PA
UK

T +44 (0)20 7631 3370
F +44 (0)20 7637 9629

E-mail anthony@michaelnash.co.uk

Kevin Gould, chef and writer

Kevin Gould is an unusual client. He swears a lot, is dismissive of most cookbooks and their recipes and disdainful of publishers and their way of working, but when it comes to talking about the creative development of Dishy and the work of the people at Michael Nash Associates, he becomes reverential.

"I've always been in awe of their creative capabilities, partly because they're so expensive, and I feel such respect for them that I always think 'who am I to take up their time?'" he says wonderingly. When he was contracted by publisher Hodder & Stoughton to write his first cookbook, he knew he wanted two things: "to do something that would turn me on and to have Michael Nash design it," he recalls.

Gould feels a huge antipathy towards the type of cookery book he calls "po-faced enterprises singularly lacking in anything I'd call humour which promulgate the idea of recipes as tests; something to learn rather than something to be enjoyed." He felt the design of these books played a large part in this perception; "Their 12-step approach and perfect photography promote the idea that cookery is something you only do if you can't afford to go to restaurants."

From the outset Gould knew that the unexplored routes he and Michael Nash were taking would not be appreciated by the publisher; "I managed to keep my editor at bay until the day before the deadline, when I delivered all the artwork, text, layouts and some of the photography." He was successful too in screening the designers from the publisher, his way of honouring them as designers, he says. "I think they only exchanged two phone calls during the whole process!"

The process, both designer and author attest, was unusual in that until Michael Nash devised the flow chart idea Gould had not written a single word of text: "Once Anthony (one half of the Michael Nash partnership) said flow charts, I knew immediately what kind of recipes I could write. They had to have multiple endings and they had to look like they'd been cooked by real people in real kitchens." To achieve this, Gould "bribed passers-by to go and make some of the recipes at home, accompanied by a photographer or a disposable camera." The results are the sort of thing anyone could achieve. They are also doing rather well in the shops (though not at WH Smith, which chose not to stock it), which has pleased Gould enormously: "Dishy turned the idea of recipes on its head. The design led the idea as much as the idea led the design in a totally co-operative way of working. It was an unadulterated pleasure working with Michael Nash," he concludes.

project 0.7 utne reader

I first came across Utne Reader while researching a book on illustration and illustrators a few years ago. This strangely titled American magazine with an impressive circulation of 260,000 seemed to attract the best illustrators in the world and the work of vibrant newcomers that were used profusely throughout its pages. The strange name – which rhymes with 'chutney' and appropriately enough means 'far out' in Norwegian – comes from the magazine's original editor, Eric Utne, and for almost 17 years the bi-monthly Minneapolis-based title has offered its readers "the best of the alternative press", focusing on cultural issues and trends and collated by a dedicated team of editors who spend two weeks poring over more than 1,000 indie mags before the final selection process begins for each issue. There is original content too, in the form of reviews, essays and reports, and the whole adds up to an eclectic and idiosyncratic publication that offers a real alternative to the slick and polished puff journalism that's become *de rigueur* for most publications. Its design history has been an interesting one, with a number of different editors, art directors and budget changes making their marks on its direction.

Utne's first issue, in February 1984, was a 12-page newsletter. Four years on the greatly expanded size still looked very much like a 100-page newsletter that seemed blissfully unaware of design sensibilities, almost purposely so. This was non-design, even at times anti-design, with no colour, two typefaces, cheap stock and very few images. It smacked of the couldn't-care-less attitude of publications like Private Eye, which still persists in using tiny font sizes, flimsy stock and minimal imagery, secure in the knowledge that its strength lies in its text. Yet Utne kept growing in size and readership, and with that came the increased income that enabled bigger design budgets; now it averages 120 pages of crisp, no-nonsense design with a strong identity and excellent use of visual material. It's a very different proposition to the sumptuous extravaganza that is Nest, the coolly self-important design of wallpaper* or the no-boundaries approach of Tokion, but its marriage of text and visuals is perfectly suited to its readership and subject matter, making it an outstanding example of editorial design.

The design direction over Utne's 17 years has been a somewhat winding and bumpy route, with swingeing budget cuts followed by boosts and a number of art directors involved in a range of redesigns, from tweaks to radical departures, but current art director Kristi Anderson has a longer track record with the magazine than almost any other staff member. She came to the magazine ten years ago from a journalism and design degree at Iowa State University, followed by stints with a Time Warner subsidiary and a couple of years as assistant art director at San Francisco's City magazine. "As far back as I can remember I wanted to design magazines; it's even in my high school yearbook," she laughs, before continuing: "Making order out of the chaos of putting a magazine together is what inspires me about being a designer; it's exhilarating to make your choices and see it take shape and come together as something you can navigate and understand more and more." At Utne she took the job of art director in 1990 and stayed for four years, leaving only to raise her family and set up a design consultancy with partner and fellow-designer Scott. The two designed a range of books, magazines, media kits and brochures before she took on the Utne contract on a freelance basis. As art director on the magazine she works on four of six issues a year, overseeing the direction of the other two which are designed by Kathleen Timmerman. Such a style of working necessitates good organisation, but through a system of work flow charts and streamlining of the print production process, which Anderson admits "will always be a work in progress", she successfully oversees the work of three designers in the art department to produce a cohesive yet fluid and always fresh product. "The development and creation of a magazine is such a mystery, some people just don't get it. But it's achieved through the most wonderful collaboration; great ideas and minds working together. The subject matter, scope and diversity of Utne's content and ethos totally inspire me," she enthuses.

How to Think Like a Genius

UTNE·READER

THE BEST OF THE ALTERNATIVE MEDIA AUGUST 98

Designer God

In a mix-and-match world, why not create your own religion?

Sex Food
Isabel Allende

Science and Soul
Ken Wilber

The Velvet Planet
Václav Havel

Mothers of Invention
Maya Angelou, Julia Cameron, Frank Zappa

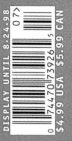

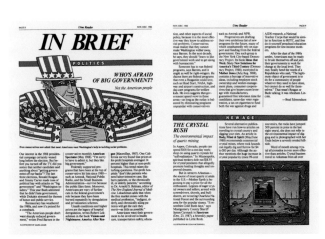

0.1 format ↙ ↖ ↓

Prior to the summer 1986 issue Utne Reader had been a newsletter, but with this issue the then art director Mark Simonson created Utne's first magazine format on an Apple Mac using Pagemaker; "years before most others in publishing," says current art director Kristi Anderson. The format was a very simple one of two- and three-column grids, while just one font in different weights and sizes was used for everything from headlines and standfirsts to body copy and pull quotes. The low budget determined the use of a lot of copyright-free imagery, and Simonson even creating his own illustrations for the issue.

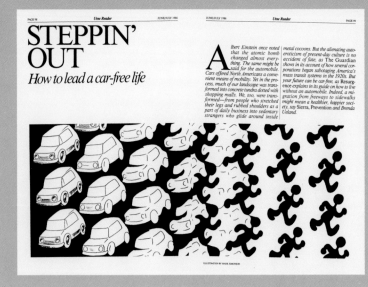

0.2 dimensions ↖

Two years on, increasing budgets allowed the use of minimal colour sections, but the format and underlying grids were still strictly adhered to. The smaller-than-usual dimensions of the magazine – 195mm x 255mm – has caused problems in the past for advertisers whose ads are designed for bigger pages. "To overcome this we have a service that does a scan of the existing film on an 'opticopy' machine which results in an eight per cent smaller image without loss of dot density," explains Anderson. "It's becoming less necessary now that more ads come in digitally," she adds.

0.3 redesign

By 1992 Utne Reader was growing quickly in popularity and new art director Kristi Anderson pushed through a cautious redesign which included introducing a mixture of one-, two- and four-colour signatures. More fonts were experimented with and a growing use of commissioned artwork began to appear and by the end of the year, Anderson was even able to begin the shift away from a strict grid format. "Editor Eric Utne wanted to update the look but was obsessively concerned with not alienating core subscribers, so the design was still tightly formulated, still 'granola'," recalls Anderson.

0.4 originality ↙ ✓ ↖

In the mid-90s Eric Utne's involvement in the magazine lessened, leading to not only this radical redesign by Andy Henderson with the Nov/Dec issue, but also more original ideas and writing from the magazine's section editors. "Eric became more willing to give design a stronger presence, while the editorial in this period became more highbrow, less granola," says Anderson. With a new modern sans-serif masthead and brand marque, a greater range of contemporary fonts, whiter stock and an ever increasing use and range of illustration, "the magazine moved away from the look of gritty alternative news publications, which is what it had always been associated with," adds Anderson.

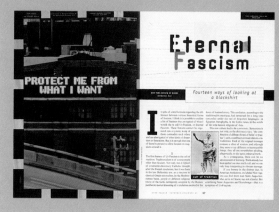

0.5 control ✓ ↘

By 1997 Eric Utne had relinquished the editor's chair to make way for Hugh Delehanty, who was joined by new art director Lynn Phelps. Phelps had more freedom than previous ADs and worked closely with Delehanty: "They kept the decision-making close, which created a different culture to the current one, though obviously it has advantages in terms of control and

decisions being made," says Anderson. "It would be difficult for myself and Kathy [Madison, the current editor] to work in that way because the people we work with are used to a lot of editorial input," she adds.

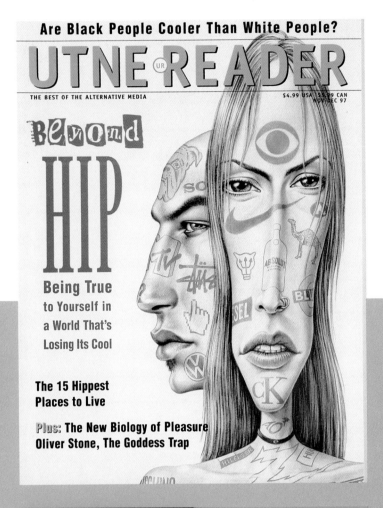

0.6 streamlining

Art director Lynn Phelps tweaked his redesign throughout the year of 1997, adding keylines and generally streamlining the look and style of the pages. His greater use of original artwork was facilitated by big increases in both art and editing budgets. "We've always been fortunate enough to draw a lot of big-name illustrators and artists who just love the magazine and believe in what it stands for, but the budget increases enabled us to approach big names who wouldn't have worked for our lower rates," says Anderson. Utne now pays $1,000 for a cover which Anderson says "for a circulation of 260,000 isn't terrible, but as it's national I'd be happier if it were $1,500. However, we do give them quite a lot of creative freedom to interpret briefs as they wish with the interior work."

0.7 illustration

Utne Reader tends to favour illustration over photography, but this is something Anderson would like to address: "Somewhere along our long route we lost the use of reportage-style journalistic photography, which I miss. We're very committed to different types of artists and illustrators and it would be nice to bring photographers back into the mix," she says.

0.8 restriction

Anderson is aware that her design ideas have to be closely tethered to the magazine's ideology and content, even if that at times proves restrictive: "Sometimes I wish it was like a funky Time magazine, but I'm not sure that that would be best for the magazine," she admits frankly. "Eclectic features that each have a unique identity are well represented by the range of artists we use though," she adds. Headline fonts too are diverse and expressive of the piece; here for the 'Razing Appalachia' piece about the havoc caused by mining Anderson chose Eurostile.

0.9 content

The Utne art team are fortunate in often knowing what the content of an article is at a time when many other editors would only be at the stage of commissioning it. This means the content very much determines the artwork: "The text, tone, cutting and direction of editing all help us determine the style that will achieve the right atmosphere for the pieces," explains Anderson, who reads the piece with a number of different artists' examples in front of her, looking for the perfect fit. Her use of fonts is similarly affected by the text: "I read the words and then just look through loads of catalogues to find a font fit. I prefer not to stick with particular fonts for headlines, but for body copy, straps and regular section heads we use Officina, Industria and Times." For the 'Seller's Market' cover feature Anderson used Gadget.

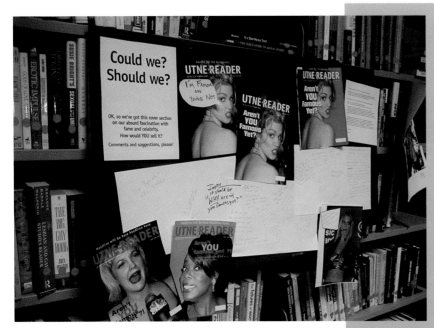

1.0 themes

The May/June 2000 cover, using Cindy Crawford to illustrate a piece about our obsession with celebrity, was a major departure for Utne Reader: "We'd used cover photos only a handful of times before and never a celebrity. This one is a paparazzi shot from a stock agency. I added the red to the right as a visual cue that this is something other than conventional celebrity media coverage," says Anderson. "We thought it might do well on the news-stand, but piss off some loyal subscribers – some hardcore fans have strong opinions of what the magazine is and should be, and they really let us have it when we stray from that," she adds. In the event, sales were not affected.

1.1 ideas

All staff in all areas are encouraged to contribute ideas and comment on colleagues' ideas. The library rack here is just one of several that display independent journalism from around the world. Section editors spend around two weeks poring over these before collating material for each issue. Three art boards display examples of artwork; necessary as the team receives around 20 samples of work daily. "Are these 'your mother doesn't work here' notices in office kitchens a universal phenomenon?" says Anderson.

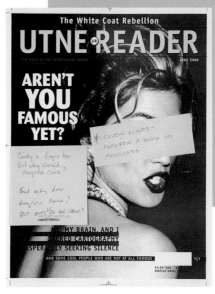

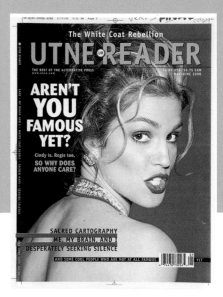

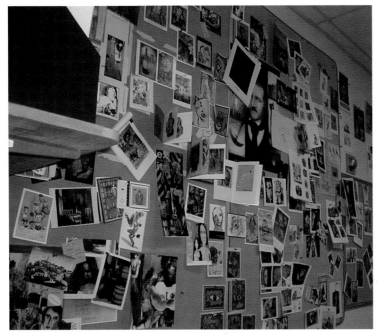

This dinky little headline caused a lot of discussion.

The story is a compelling piece by a writer who suffered brain damaged from a rare viral attack. He describes a constant awareness that his "new" brain routinely thwarts his intended actions, forcing him to be completely deliberate about things that were effortless with his "old" brain.

Editor Cathy Madison, Managing Editor Craig Cox, and I thought the headline "Me, My Brain, and I" was great, but Senior Editor Jeremiah Creedon—who was especially close to the piece after having spent several days meticulously editing the piece from over 6000 words to just over 4000—completely despised it. He thought the "Me, Myself, and I" reference too flippant.

In the design I kept coming back to this idea of treating the headline as if it was unpredictably "damaged" by a computer virus. You know—you're working along nicely on a simple task and suddenly the computer starts doing small, annoying things that make you feel crazy. I wanted it to be clinical-looking—not overly manipulated and "Photoshoppy"—hoping that gives it a subtly unsettling feel. I believe this helps to move it away from flippancy.

The editors felt unanimously uncomfortable with the treatment at first, because it looks like a mistake. (As in, "Oh my God, this went through three editors, two proofreaders, 42 million printouts, and it still went to press with the comma on the wrong line!") But of course that's the point. It works *because* it looks like an odd mistake. (I hope.) Cathy offered a good suggestion: To enlarge the "I used to be able to think." (first line of the story) on the right-hand page so that it reads almost instantaneously with the headline. Each reinforces the meaning of the other.

Jerry still doesn't like it.

ME, MY BRAIN, AND I

ILLUSTRATIONS BY MELISSA SZALKOWSKI

58 MAY-JUNE 2000 UTNE READER

Art by Melissa Szalkowski, a digital artist who is a new favorite of ours. (Her # 718-782-7193.)

All files were created in Photoshop and e-mailed to us as RGB jpeg files, which we converted to CMYK tiffs.

1.2 process

This feature for the May/June 2000 issue of Utne Reader used the work of digital artist Melissa Szalkowski to illustrate a piece by writer Floyd Skloot about a viral attack which damaged his brain and the consequent effects on his actions. Anderson explains the relationship between art and text on the fold-out notes attached to the spread.

I USED TO BE ABLE TO THINK.

My brain's circuits were all connected and I had spark, a quickness of mind that let me function well in the world. There were no problems with numbers or abstract reasoning: I could find the right word, could hold a thought in my mind, match faces with names, converse coherently in crowded hallways, learn new tasks. I had a memory and an intuition that I could trust.

All that changed on December 7, 1988, when I contracted a virus that targeted my brain. More than a decade later, my cane and odd gait are the most visible evidence of damage. But most of the damage is hidden. My cerebral cortex, the gray matter that MIT neuroscientist Steven Pinker likens to "a large sheet of two-dimensional tissue that has been wadded up to fit inside the spherical skull," has been riddled with tiny perforations. This sheet and the thinking it governs are now porous. Invisible to the naked eye, but readily seen through brain imaging technology, are areas of scar tissue that constrict blood flow. Anatomic holes, the lesions in my gray matter, appear as a scatter of white spots like bubbles or a ghostly pattern of potshots. Their effect is dramatic; I am like the brain-damaged patient described by neuroscientist V.S. Ramachandran and science writer Sandra Blakeslee in their 1998 book, *Phantoms in the Brain*: "Parts of her had forever vanished, lost in patches of permanently atrophied brain tissue." More hidden still are lesions in my self, fissures in the thought process that result from this damage to my brain. When the brain changes, the mind changes; these lesions have altered who I am.

"When a disease process hits the brain," writes Dartmouth psychiatry professor Michael S. Gazzaniga in *Mind Matters* (1988), "the loss of nerve cells is easy to detect." Neurologists have a host of clinical tests that allow them to observe what a brain-damaged patient can and cannot do. They stroke his sole to test for a spinal reflex known as Babinski's sign or have him stand with feet together and eyes closed to see if his ability to maintain posture is compromised. They ask him to repeat a set of seven random digits forward and four in reverse order, to spell *world* backwards, to remember three specific words such as *barn* and *handsome* and *job* after an unrelated conversation. A new laboratory technique, positron emission tomography, tracks radioactively labeled compounds that essentially light up specific brain areas being used when a person speaks words or sees words or hears words, revealing the organic locations for various behavioral malfunctions. Another new technique, functional magnetic resonance imaging, allows increases in brain blood flow generated by certain actions to be measured. The resulting computer-generated pictures, eerily colorful relief maps of the brain's lunar topography, pinpoint hidden damage zones.

But I do not need a sophisticated and expensive high-tech test to know what my damaged brain looks like. People living with injuries like mine know intimately that things are awry. They see it in daily activities, in the way simple tasks become unmanageable. This morning, preparing oatmeal for my wife, Beverly, I carefully measured out one-third cup of oats and poured them onto the pan's lid rather than into the bowl. In its absence, a reliably functioning brain is something I can almost feel viscerally. The zip of connection, the shock of axon-to-axon information flow across a synapse, is not simply a textbook affair for me. Sometimes I see my brain as a scalded pudding, with fluky dark spots here and there through its dense layers, and small scoops missing. Sometimes I see it as an eviscerated old TV console, wires all disconnected and misconnected, tubes blown, dust in the crevices.

Some of this personal, low-tech evidence is apparent in basic functions like walking, which for me requires intense concentration, as does maintaining balance, and even breathing if I am tired. It is apparent in activities requiring the processing of certain fundamental information. For example, no matter how many times I have been shown how to do it, I cannot assemble our vacuum cleaner or our poultry shears or the attachments for

BY FLOYD SKLOOT **FROM CREATIVE NONFICTION**

T HAPPENS WHEN A
VIRUS ATTACKS THE
ILE LINK BETWEEN
BRAIN AND MIND?

Here is a long description of a seemingly minor art/edit problem that actually has a fair amount of significance in a magazine devoted to *reading*.

In *Utne Reader*, when a feature story is an excerpt from another publication (which most of ours are, hence the "Best of the Alternative Press" tag) the editorial style is to print the author's byline/some kind of slash or color shift/ then the name of the publicaition. No "From." Because the name of the pub in this case was a journal called "Creative Nonfiction," no matter how I designed it, it came off looking like it was a *feature category* rather than the title of the source publication. Editors were reluctant to alter their style, but eventually agreed that we needed words to make it clear: an edit solution rather than a design solution.

There is so much that designers can and should do to help readers understand and navigate the information we present, but sometimes you just gotta ask for different—or more—words to make something clear.

ME,
MY
BRAIN
,
AND I

I USED TO BE ABLE TO THINK.

1.3 flat planning ↖

Production manager Kathy Braeunig draws up the monthly flat plan, which as with any magazine changes from day to day to accommodate the constantly changing needs of the ad team, advertisers and editors. "Pagination is like putting together a puzzle where not only do you have pieces missing, but where the picture on the face of it is constantly changing," says Anderson. Braeunig's calendar and editing process help guide the work flow over the production period, although they are constantly trying out new ways of managing the process.

1.4 illustration ↖ ↖

These sketches by artist Martina White were sent in as preliminary ideas for a piece on creating personal maps. The detailed ideas and development of the drawings shows the kind of commitment to Utne Reader that Anderson values highly: "I love to work with illustrators who know and love the magazine, people who come to it really caring about it. That's not to say I won't use people who don't know our work, but it is nicer to use those who do," she says.

1.5 diversity

Assistant art directors draw up the concepts for their own pages, taking responsibility for the design and layout for them. "I have some concerns about four people (three assistant ADs and Anderson) seeing design through their own sensibilities, but I think the energy driving all those diverse interpretations can be great; I just have to know when to rein things in regarding styles, formats and the overriding direction of the magazine," says Anderson. This opinion piece dealing with a growing identity crisis for Latino Americans – their social, emotional and physical space in society – was overseen by assistant art director Jessica Coulter, who describes the process overleaf.

Familiar Strangers

Jessica Coulter, Utne Reader's

comments

project credits

Editor Kathy Madison

Art Director Kristi Anderson

Utne Reader
1624 Harmon Place
Minneapolis
Minnesota 55403
USA

T +1 612 338 5040
F +1 612 338 6043

E-mail info@utnereader.com
www.utnereader.com

assistant art director

Jessica Coulter, assistant art director

As one of three assistant art directors at Utne, Jessica Coulter is in the fortunate position of seeing articles through from initial concept to typesetting and prepress, and here she describes the development of one project.

"Soapbox is a two-page opinion editorial piece that appears about four times a year in the newsy 'New Planet' front section of the magazine. It's a serious article and meant as a piece in between a news article and the deeper read of the cover and feature section. This particular piece is about Latinos and their identity, republished from El Andar. I begin by giving the article a read, and while doing that I usually jot down notes of symbols used or poignant images that come into my head while reading the article. I discuss with the editor the intent of the article and how we best think it would communicate. A photo of a character mentioned? Illustration – do we want it to reflect the culture we are talking about or should it communicate the emotional mood?"

"We decide the piece is about a human story and that narrows things down; I know I am looking for a certain type of illustrator. The piece deserves a portrait of some kind, not too realistic, but I am looking for someone who can convey emotion in a facial expression, with just enough abstraction to add a level of uncertainty, questioning. I pick a sampling of artwork from our files (we get about 20 submitted every day) and run them by the editor; editors are an important visual gauge but as art directors it is our duty to bridge the vacant space between idea and actualisation."

"Based on two postcards and a look at his website, I phone Bill Tsukada, an illustrator none of us has ever worked with. I appreciate the consistent conceptual depth of his work; his compositions are original, his colours refreshing. That's something about Utne, partly because of our alternative editorial (i.e. low) budget, but mostly because of our desire to pave new ground we never flinch at the chance to work with someone new. I call him, then send him the story; I prefer to give illustrators a chance to conceptualise their own ideas before I plant any visual seeds. Bill gives me a bunch of little thumbnails and we decide on one that I believe will eloquently communicate the article and draw people into reading it. I usually communicate with the artist a couple more times; but between the thumbnails and the final art I am just expecting a delightful surprise – and usually get it!"

project 0.8 I.D. magazine

American I.D. magazine, as opposed to Brit style bible I-D magazine or food industry title id magazine, carries the subtitle 'The International Design Magazine' and indeed is regarded as one of the foremost authorities on international design from a range of disciplines – though industrial design is a particular forte and over the years many people have assumed that was what the letters stood for. I.D. is a trade magazine but has always been highly prized by anyone with an interest in design; consumer magazines come here to discover the best in new design and the best new designers, commercial companies use it as a valuable source tool, design fans and students buy it to see stunning designs before they see them anywhere else. And as with any magazine whose business is design, the editorial design has to live up to the contents; ensuring it does not overpower the work on show but compliments it by finding the right balance between established graphic design principles and the best of new fonts and styles.

Until last year the magazine was edited by Chee Perlman. Perlman's hand on the direction of the magazine was a strong one, so much so that when she resigned last year so did all the editorial team, barring the editorial assistant. Speaking just a couple of months after Perlman's departure, then creative director David Isreal recalled the period as "crazy. It is hard to comment on the process of making the magazine at the moment because with each issue it has changed drastically depending upon who is left. We have had guest editors in the meantime, and the issues have continued without a hitch – which I must say is pretty amazing." The obvious upside of such an unusual position was, he added, "having so much autonomy in determining the design direction."

Perlman's style of editorship on the magazine fostered a way of working that Isreal describes as "what made I.D. unique; under Chee Perlman, there was an atmosphere of total collaboration. The editorial and art department closely collaborated on all aspects of the magazine. The art department had a large say in story directions and ideas, and the editorial people helped determine the visual direction of a story," he explains. When Isreal says 'art department' you imagine a large team including production manager, picture editors, tech support, designers, assistants and so on – in fact, the department consisted of Isreal and Miranda Dempster, senior art director: "No production people, no photo editors, just us doing all aspects of the magazine. Which allows us total control," enthuses Isreal. Major production issues are dealt with by I.D.'s parent company, F+W Publications in Cincinnati. While there are just five issues of I.D. a year, there are also a number of specials and sourcebooks, including the Interactive Media Design Review covering the best in digital design; the Annual Design Review, gathering together the best in consumer products, graphics, packaging, furniture, environments, equipment, concepts and student work; and the Annual Design Sourcebook or Buyer's Guide to Design, containing resources for graphics, products, packaging, environments, interactive media, computer hardware, stock photography, materials and supplies. These three alone form a comprehensive library of the world's best design and, added to the regular issues of the magazine, build up an example of editorial design that would leave many much better funded and staffed consumer titles standing. Over the years Perlman and her creative directors seem to have been able to find and dissect the most unusual areas of design, a good case in point being an amazing issue (Sept/Oct 1999) dedicated to Las Vegas; everything from the design of the betting chips and casino carpets to the commercial and residential buildings and lighting was beautifully shot, examined and celebrated through the use of gleefully kitsch fonts and colours. By contrast, a later issue featuring the Pantone factory was cool, clean and clinical. Such imaginative exploration of the design of such non-design areas is what has always made I.D. stand out in the design magazine arena.

I.D.

The International Design Magazine

$6.95 US / $9.50 CAN MAY 2000

INSIDE PANTONE: The Spectrum Redefined

FLYING LOW: Airplane Seat-Beds

QUIZ SHOW SETS: Final Answers

SHELF LIFE: Irma Boom's Books

NEIL BARRETT: Son of Samsonite

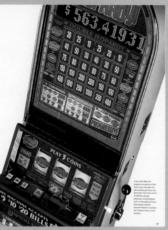

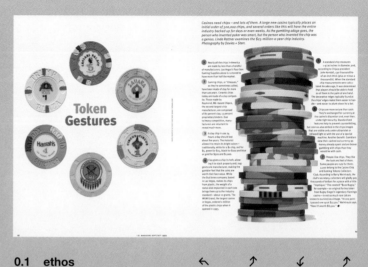

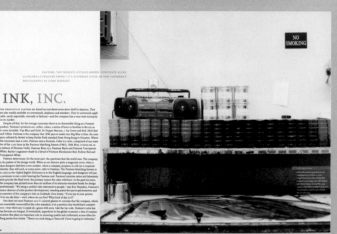

0.1 ethos ← ↑ ↙ ↑

David Isreal, creative director of I.D. magazine last year, describes the magazine's design ethos as "clean, simple, design-y without being trendy, modernist but not slick." Prior to Israel's arrival, one of the strongest issues I.D. had published in a long time was a special on Las Vegas, which amply illustrated its exceptional use of photography, fonts and layout – and Israel's assertion that "the look of the magazine is considered on an equal level as the editorial content."

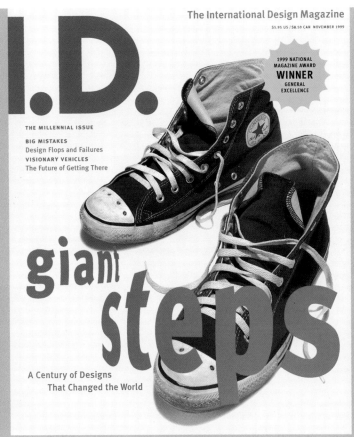

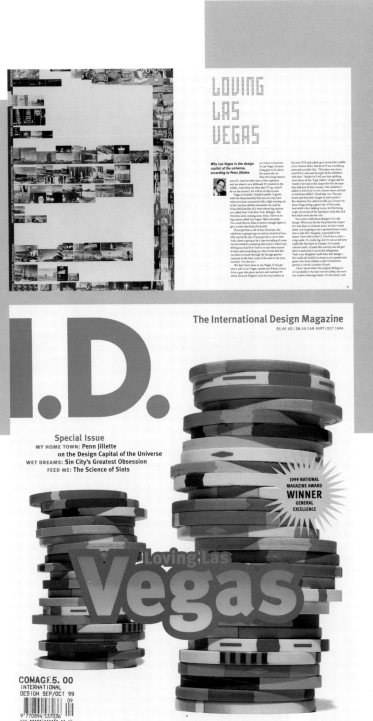

0.2 direction ← ↑ ↓

The November 1999 issue was the first one that Israel worked on, and he strongly felt that the visual direction needed to change from the start. However, "the content was already together when I arrived so I had to scrape together the stuff and get it out the door very quickly," he recalls. Consequently, there are certain elements Israel was less than happy with: "I really hate the cover; the sneakers are too pink and weird; with hindsight I would have made a totally different cover." He is happier though with the spread on disposability: "I think that it is one of the nicer ones in that section – clean, simple and straightforward."

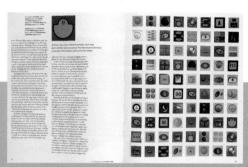

0.3 grid work ↑ ↘

"I think this feature about push buttons by Peter Hall came together really well," says Israel. All the pictures were chosen by the art department with editorial input, while the grid of small button pictures was shot around the I.D. office and neighbourhood with a digital camera. Israel believes "the heavily gridded text holds the three spreads of the feature together and the button grid makes a natural jump to the phone pad visually, giving the whole the same feel."

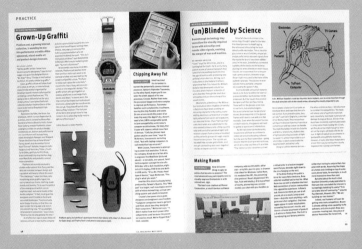

0.4 illustrations

These spreads forming part of a big feature on the worst products of the century illustrates Israel's inventive approach to editorial design. Where the obvious route would have been to shoot the actual products, he decided to use illustration. "I have always thought that I.D. could use more illustration and that it had been somewhat ignored in the past. So in this case, because it became really difficult to do the photo research necessary to find quality images of all objects, I decided illustration would work well and help differentiate the section from the best of the century stuff."

0.5 navigation

Towards the back end of the magazine are the less glamorous news and source sections, including Practice, Reviews and Calendar. These are printed on a different, matte, stock to the rest of the magazine and only in spot colour simply for reasons of cost, but the difference makes them quickly and easily identifiable, a useful function as they are the sections that readers are likely to use to find information quickly and repeatedly.

0.6 grids

House fonts on I.D. are MetaPlus, Metro Meta and Scala. Column grids are used for the regular front and back end sections. "We also have a loose grid that is regularly used for features, it offers enough flexibility to provide structure without trapping us," says Israel.

0.7 photographers

All photographers are found and hired by Israel. "We collaborate closely with photographers and we want their ideas and input on everything being shot. I go to all shoots and choose to work with people whose vision coincides with that of the magazine or story," says Israel.

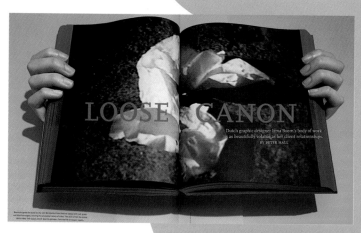

0.8 sourcebook

The annual sourcebook issue of I.D. is not the most exciting of publications to design, essentially acting as a list of companies that offer services in various design areas. "Consequently this issue is usually very dull," says Israel, "but we decided to take it to a new level aesthetically. We are really pleased with the cover and divider pages, which were all shot by Mikako Koyama. I think they set a nice tone for the issue," he says.

0.9 clarity

"Because the sourcebook is squeezed in during a crazy time of the year it has to be done quickly so usually there is not a lot of time or effort put into it. This time I decided it should look nicer." The idea was around clarity and transparency, "tools of the trade so to speak, but overall there was a theme of transparency," says Israel. He chose the objects visually and by subject matter, for example the contents page shows plastic Letrasets laid over each other, the graphics divider, pencil sharpeners and the product divider, French curves.

1.0 themes ↗

The I.D. Forty issue is one of the most important of the year, taking a theme and looking at 40 examples within it. The 1999 theme was 40 designers under 30. The cover and display face throughout the section is Bolt, but Israel redrew it and added some rounded corners for the cover. From the range of products featured in the section he decided to use a fruit preservation tank, the Vanitas fruit bowl designed by Julian LaVerdiere, because "it was something crazy that we'd never seen before. It gave the cover a little hook, with the cover lines." Israel is keen to use fewer cover lines generally ("no cover lines would be best"), believing it "makes for a more striking image and allows the type and image to work off each other without giving everything away."

1.1 background ↓

"The general idea behind the design of the section was to give the issue a structure that was young and fresh. We had to organise the little statistic box info and give each page a headline. There were a lot of pragmatic concerns that were taken to this futuristic sci-fi place – as the people covered are the future." Overall Israel was pleased with the results: though feeling "it works better in some places than others."

1.2 contrast ↙ ↓

By contrast to the previous fresh clean look of the I.D. Forty issue, the next issue saw a cover that was a lot busier, and perhaps works less successfully because of it. "The type is Metaplus, and there was no grand idea except that this was the cover story and it needed to be represented," states Israel boldly. The contents page, by contrast, is very calm and diffuse, showing the eclecticism of the issue, he adds; "It came about because we really loved that picture."

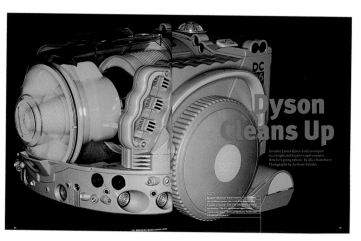

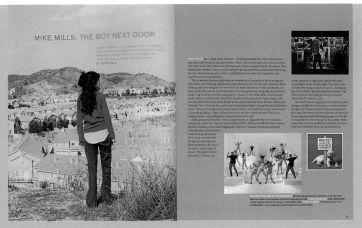

MIKE MILLS: THE BOY NEXT DOOR

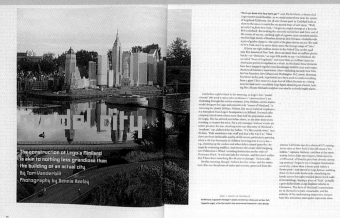

The construction of Lego's Miniland
is akin to nothing less grandiose than
the building of an actual city
By Tori Vanderbilt
Photography by Dennis Keeley

1.3 features ↑ ↓

While Israel admits he is less than happy with the cover, he believes some of the features in the same issue worked well. The ones he particularly likes are a feature on video-maker and artist Mike Mills ("because I really like and admire his work. I like the colour choices for the backgrounds and think the style of the story relates to the content well"), one on Lego's Miniland ("again, the content and the visuals directly relate") and the graphic designers' Manifesto, which uses no imagery because "there really wasn't much imagery to choose from and we only had four pages," says Israel. "A typographic solution seemed more appropriate to the content and structure of the story," he adds. And the pastel palette? "A sort of play on CMYK and Post-It notes."

A MANIFESTO
With Ten Footnotes by Michael Bierut

A critic's response to the recently resurrected "First Things First" call to arms.

1.4 colour ↑ ↓

The May 2000 issue, whose cover story was a profile of colour supremos Pantone, was printed with two covers; a yellow one for the news-stands and blue for subscribers. The two were part of a new range of colours which were to be released by Pantone later that year. "Overall we were very happy with this issue; it is strong editorially. The minimalism of the cover was a reaction to the busyness of the previous issues, and it was really appropriate to the content of the Pantone story," says Israel.

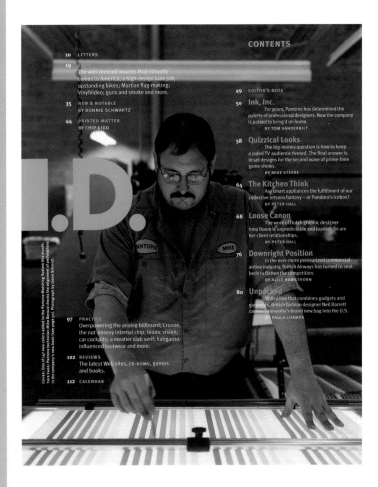

Chalkie Davies, Davies + Starr,

comments

project credits

Editor-in-Chief Chee Perlman

Creative Director David Israel

I.D.
116 East 27th Street
Floor 6
New York
NY 10016
USA

T +1 212 447 1400
F +1 212 447 5231

E-mail edit@ID-Mag.com
www.IDonline.com

photographer

Chalkie Davies, photographer

A large part of I.D.'s beauty lies in its photography, not just the way the images work with body copy, display fonts and layout, but the actual quality and intensity of the images themselves. The magazine uses a number of photographers, but one it has had a continuing relationship with for some four years is New York's Davies + Starr. Chalkie Davies (the 'Davies' part of the name) recalls meeting ex I.D. editor Chee Perlman through the late designer Tibor Kalman, and likes working with the magazine because "they pretty much give us the freedom to do what we want, and what they give us is always really interesting stuff."

In the 21 years since its inception (with the last 12 in New York), Davies, his partner Starr and other photographers with their own studios have moulded the company into a kind of photo factory: "We firmly see ourselves as a service industry. And we don't have individual credits for our work, just the umbrella name of Davies + Starr, because we're not important; the most important thing in the room is the picture yet to be taken."

"We have six still-life sets on which we take technically precise pictures – in up to 16 different ways – of everything from lipsticks to cars," says Davies. Product shots are a large part of the output at the factory, where clients include Apple (packaging for the G4 range), Clinique, Donna Karan and of course, I.D. "With I.D. we'll try and find the point of the design in the object, what the designer saw when he or she was designing it," explains Davies. "For example, most people's view of a shoe would be from above. But the designer's point of view would be in profile, so that may be the best way to shoot it."

Davies and many of the photographers at Davies + Starr have been working as photographers for more than 20 years, and he finds that consequently "the technical challenge is the most interesting one for us; working out how to shoot a pinhead, or fruit flies (without killing them under the heat of the lights!), or an explosion... beyond that, it's good working out how best to show something. With I.D. for example, they'll phone us and tell us what they want, then send us a bunch of stuff to be shot. Our work for them then tends to be very simple; there's no forced perspectives and most of the objects are shot on glass from above, suspended on invisible wire or shot lying down – we get a different way of seeing things, and it's a way of seeing that Chee likes."

All the pictures are taken as 5x4 or 8x10, so there are no endless rolls of film and contact sheets, just a few perfectly thought through images that minimise time and waste. "It's really quite simple; you send us an object, we'll send you the picture of it," says Davies.

project 0.9 play cd-rom

Each year the prestigious Netherlands Design Institute holds a conference entitled Doors Of Perception, a three-day event encompassing themes and movements in multimedia, the internet, design and culture. The focus of the fifth Doors of Perception, held in November 1999, was 'play', and in keeping with the subject matter and audience for the event, the NDI commissioned an associated website and CD-ROM. These were both developed by the 'Doors 5 live team', made up of students of the EMMA in Interactive Multimedia, a multidisciplinary international graduate course of the HKU, Faculty of Art, Media & Technology in the Netherlands.

Just as the Play website was designed as a dual-purpose vehicle which would provide a virtual version of the conference for those who couldn't attend the analogue one but also involve them in a playful way, stimulating ideas and dialogue, so the CD had to go way beyond acting as an archive of the conference's contents. As project leader Iris van den Heok puts it, "This CD was developed so that users could experience the rich content of the conference on learning, enter into the realm of play, and savour the rich atmosphere of the three days. It presents the proceedings of the conference and preserves the contributions and the ideas of the speakers and visitors, but its concept is based on some of the interesting ideas on play and gaming which came out of the conference. We focused especially on the ideas about the creative and playful role of the user in new media." Key to developing the core concept of the CD and interpreting the conference were: a focus on the creative and playful role of the user in new media; an understanding that every visitor makes a personal version of a conference (individual story); the realisation that everyone builds up a personal 'version' of the event or game (making 'sense' of the given material, finding out the rules, making the connections and interpretations and playing with the material).

With this in mind, van den Hoek and her team decided the CD had to allow its users to play an active and creative role, become the director of the story and mould the content to his or her interest. Beyond that, they came to the conclusion that there was not just one definition of play, so the CD should not have one interface, but four. After that came what van den Hoek calls "an intensive period of brainstorming and the exploration of different models; some were very playful and deeply structured, some were realistic but just too complicated."

The creative team behind Play was a large one, which was not without its problems. "Nine of us worked closely with the assignment giver or client, designer Kristi van Riet. She became one of us, which is quite special I think. Between us we had four screen designers but needed to have one design in a creative environment that had to be very flexible because a lot of video and text had to be incorporated, preferably in a non-linear way. Ultimately we were trying to implement a lot of information in a playful way, to make a whole of it, to be on the edge, to be informative and creative, design-wise, and to fit the information in comprehensible storylines."

The final product includes 200 video-clips, all the conference lectures, quotes from speakers, discussion panel contents and interviews with speakers and visitors; all presented in a multi-linear approach over four interfaces that allows each user to build their own version of the event and explore myriad ways of seeing, interacting and evaluating. Not surprisingly, it won rave reviews from the international design press and a Best Student Award 1999 of the Macromedia Gallery.

doors of perception 5

0.1 structure

"The Play CD-ROM represents the Play conference in a number of ways; it had to include a section with all the lectures, but also give access to highlights and present main topics. Even more importantly: it is totally based on ideas on play and learning which came out of the conference," says Raimond Reijmers (interaction design).

0.2 presentation

During the Doors of Perception conference, speaker J C Hertz gave the Play team the idea for the original interface and content of the CD. Speaking on the definition of play, Hertz commented "we don't have a model. The one that I've come up with so far... is if you take the category of play, as the big circle and the Van diagram, and anything you can do with it digitally, or I think non-digitally, there are four things that you can make; a game, a toy, (which is very different from a game because its chief quality lies in the qualities of the object), a story, or a tool, which is the crayon, the digital paint program, the thing which allows you to make something else." This paved the way for the presentation of the conference material in an inventive and playful way that would allow the user true interactivity and intervention with the content and interfaces.

Janet Abrams
Lecture | About

◇ My name is Janet Abrams; I'm with the Netherlands Design Institute. I'm the XY chromosome on the program team for Doors 5, and I'm the editor of If/Then. And just in case you're not thoroughly bored with hearing the role call of people at the conference who are in the book of the conference, I will repeat the participants include Pauline Bax who has written about the project that Caroline Nevejan talked about this morning, Demi Dubbel. We have Gong Szeto, as he said, appearing both in the Knowledge Maps piece, and in the round table discussion on toys-versus-tools, called Long Lake III. There are pictures by Helen Levitt, although we had to cut short the screening today of her film In the Street. You'll also find contributions by Uri Tzaig and Danny Goldberg who will be speaking on the panel later on. In addition Femke Wolting, who is also joining us this afternoon, has written a piece that you'll find in this issue. And Alan Kay, who'll speak tomorrow, has an essay. This was a magazine that we'll officially launch tomorrow. It's sold out at the bookshop I've just been told.

This afternoon's panel, which is called 'Play channels, media hybrids and the future of experience' brings together a large number of people for the discussion session which I

Toshio Iwai
Lecture | About

This is a little bit unhappy birthday - but I think this is very beautiful music. I don't know who has a copyright of this music.

Anyway, when I met this little music box, I was very comfortable about understanding a structure of music. Then I started working on a computer to make a sort of expansion of this kind of traditional musical instrument. So I would like to go back to the video.

This is very simple software which is also running on Super Nintendo. Here it has the same function as this little music box, but instead of making lot of holes on a paper, you can use a mouse to point at the stars in the sky. The name of the software is Starfly, like firefly, and you control this little box. You can change the speed of the music. You can reverse the direction. Or even you can grab this line and then make a sort of stretch. There are a number of different instruments. And when you change the instruments, the light effect on the star is also changed. I designed these light patterns very carefully because for me, the combination of the animation, image and the sound is very important.

Here are some examples which my friends created or I created. This is a good example. Here's typical Japanese music. Here I would like to show another possibility of using this

0.3 multi-linear ↑ ↗

The Play team eschewed a linear approach to the conference contents, but they did have to find ways to incorporate all the content of the speeches plus biographies and background info, along with some representation of the live performances at the event. Remon Tijssen (interface, graphic design) believes that the Play team's solution successfully translated participants' performances to the CD through the multi-linear approach it took. Raimond Reijmers (interaction design) adds: "We came upon the idea of presenting quotes of speakers on topics instead of giving the conclusions ourselves. About 230 quotes were chosen and distilled to arrive at a way of revealing more or less 'objectively' the most important themes and crosslinks of the conference."

0.4 delivery ↓

Folkert Gorter (design and interfaces): "You might assume the aural delivery is the perfect form of exchanging information, but I think the CD medium has aspects to it that can enormously enhance information. What we tried to do was immerse ourselves in the information to be delivered, going over it as long as it took to completely understand what it was trying to communicate, before trying to enhance it by the way we presented it. The way in which you arrive at a certain chunk of information actually reflects the ideas presented by that chunk of information."

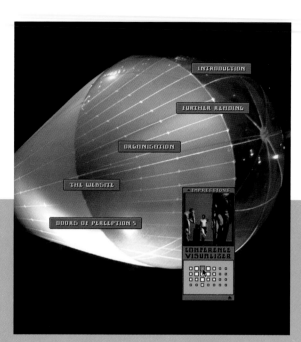

0.5　browsing

"Originally we wanted to present the quotes in non-linear clusters, but eventually agreed that it would be better to serve the needs of different kinds of users. So we created the ability to browse in a non-linear way in every section (see the little content overview in the middle of every screen) and at the same time, for the more passive users, we presented the quotes in a logical sequence. All four sections have such a unique storyline or 'quoteline' as a backbone. In this way the content gives an impression of what was going on at the conference. On top of that these quote sections can be an interface to the lectures (with every quote a link to the full lecture text and speakers biog is provided)," explains Raimond Reijmers (interactive design).

0.6　interactivity

One interface, Tools, is particularly innovative in both technique and design. "We wanted it to be both a graphical and abstract experience. It's literally a tool, the user's paint tool, in that you can use it to make your own drawings with the elements we provide," explains Remon Tijssen (interactive design). "The cursor's behaviour is adjusted by your movement, every pixel you move, you get something back. When you stop you get the next point, the next keyword in the narrative. You decide when to stop, when to go on and how fast to go through the content, not by clicking, but by moving. The keywords are previews of the quotes, the actual content, the highlights of the conference. The tool doesn't add anything concrete to the actual content, but you have to see the added value in the way this tool works and allows the user to browse through the narrative in an emotional way. Everybody likes to create something nice. Our job was to create the boundaries. Within those boundaries everybody can create their own picture, the picture of your way of navigating."

0.7 integration

The mix of disciplines was challenging but extremely rewarding, and Tijssen believes that Tools illustrates that mix well. "From a design point of view it integrates graphic design, interface design and usability just as we'd like to see it. There was a lot of discussion about the transparency and size of the user-created graphics. How transparent should the circles be? Should we not fill them up, just use the outline? Also the difference in size when your mouse movement accelerates or decelerates is an important element in this issue. When the circles are not transparent enough or get too big too fast, the user starts moving his mouse and in no time the screen is split up. However, when you balance the way the circles react to your movement, it makes the tool softer and makes you able to have some fun while browsing through content. But most importantly, the tool has to stimulate movement, which keeps you going in receiving the interesting content of the conference."

0.8 process ↑ ↓

Dennis Jansen (video) describes the process of developing the CD as "horizontal; it's like building a house where from the ground up every element of it was built simultaneously with the plumber next to the electrician, next to the carpenter. This way of working was very nice because as problems came up they could easily fit into the new plan, and sometimes surprising concepts appeared that weren't part of the original plan."

0.9 progression ↑ ↓

All the Play members agree that what they'd planned from the start was not what they ended up with, but that the project progressed as it developed. But as Dennis Jansen (video) says, "the concept and accessibility of the content and ideas were exactly what we wanted." Folkert Gorter (design and interfaces), expands on that: "Initially, we had no clue as to what the thing would eventually turn out to be, it took shape along the way, was completely trashed half way, came back and arrived at its final destination, which was one of a million possible directions."

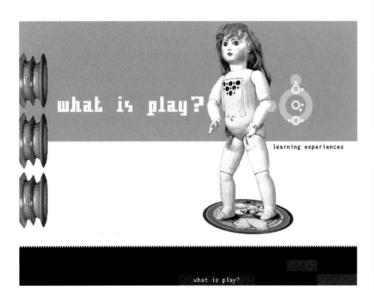

1.0 games

In the Games section of the CD, users have to play a game to catch the content as it falls from the top of the screen. "The form is based on a pillow fight which happened at the conference spontaneously (with the chair cushions). Catching the content gives you more power and builds up your strength," says Raimond Reijmers (interactive design). The content here is about the games industry, including new forms of gaming and more esoteric topics like the gamelike rules of financial business.

1.1 narrative

Stories more than any other section focuses on philosophical quotes from the conference about the ideas behind playing and learning. It enables the user to build up his own narratives, laying content from a number of different speakers to create a new narrative structure. "The content is represented as non-linear clouds, but the only way to 'read' it is by organising it into your own linear story with a beginning, middle and end," says Raimond Reijmers (interactive design).

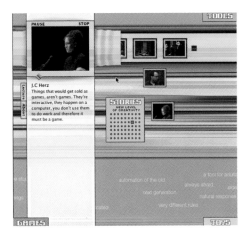

1.2 toys

In Toys, old toys tell you about new toys and new forms of playing. The content reveals the way new toys enrich education and even the design process.

1.3 brainstorming

Many of 3D animator Stijn Windig's designs and animations did not make it to the final CD, but he found the process useful and informative: "I got to explore the use of my skills in a fun and educational way of working. The design process veered wildly in every direction at the beginning of the project, with brainstorming spanning the relatively plausible to the distinctly weird... I'd say the final CD is a nice snapshot of the skills of a whole bunch of different people at a certain point in time that has somehow crystallised into an actual finished product."

1.4 synchronisation

"We labelled our way of working on Play 'concept by design'. It's mostly based on prototyping: you start off with playing, experimenting and trying out different ways to solve a small part of the bigger problem. There were times when it was hard to sync everyone up, but in the end it proved to be the perfect combination for doing a project like this one. While there were sub-teams working separately on different things like information management, graphic design, project management, video editing, 3D-modelling and interface design, each person was continuously involved in the overall ideas and development of concepts, which ensured that the generation of ideas was as diverse as it could possibly be," concludes Folkert Gorter (design and interfaces).

CREDITS
colophon the making of the project

Dennis Jansen

Menno Hartog

Raimond Reijmers

orter

Kristi van Riet

at

John Thackara

John Thackara

Iris van den Hoek

Remon Tijssen

Mathieu Doorduyn

Stijn Windig

PLAY
allow events to change you

make mistakes faster

doors of perception

Raimond Reijmers, Play's

comments

project credits

The Play Design and Production team comprised:

Dennis Jansen

Folkert Gorter

Galit Eilat

Iris van den Hoek

Kristi van Riet

Mathieu Doorduyn

Menno Hartog

Raimond Reijmers

Remon Tijssen

Stijn Windig

CD-ROM produced by **Van Riet Online Productions**

E-mail d5live@dds.nl

designer

Raimond Reijmers, designer

Raimond Reijmers, one of the interaction designers on the Play team, outlines some of the main themes and factors in developing the CD.

"Our goal with Play was to let interface, concept and content tell more or less the same story. Of course it's our version of that story, but we were conscious of wanting to provide an open structure where users could make their own conclusions. For us an archive was not enough. We wanted to highlight the crosslinks between the lectures; the themes and topics that were characteristic for this conference. If you ask two attendees of a conference for their impressions they will tell a different story, and we were aware that a CD-ROM of 'proceedings' should give space to these different impressions; it's in the nature of new media to provide structures where people can make and remake their own stories."

"With Play we wanted to stimulate play in content browsing, because we believed that the process of getting to the content was as important as the content itself. We looked carefully to the balance between playful elements and clear no-nonsense content browsing, because in the end it has to be clear how it works. In working out how best to turn a conference into a piece of software, we discovered that the best thing was to find what was specific about the medium and focus on that, because, like Play itself, software has many forms."

"Our arrival at the final product was aided by the fact that our way of working on Play wasn't the 'traditional' one of concept, design, production. Designs are based on a concept, but the concept can change. You discover something in design – interface as well as graphic design – when you experiment with the material you have and the techniques you can use. In some cases you have a vague idea and just start playing with it from a design point of view; just trying out what works and what doesn't. In other cases you have a very clear idea how something should look and work, and when you make it, it just doesn't fit. You have to dare to drop everything you had and start over again completely." In the case of the Play team, these ways of working informed the process but enabled them to arrive at a new one, as the captions explain.

project 1.0 web graphics

The internet has exploded in a very short space of time from a small academic text-based network into a massive commercial enterprise. On the back of the Net another industry has also blossomed, Web design education. One of the best-known tutors and authors in this area, Lynda Weinman, has produced a series of books on Web graphics, techniques and specific software packages such as Photoshop and Dreamweaver. As the Web and software is frequently updated so the books themselves have also been revised and the hugely successful Designing Web Graphics is currently at version three. On all the 13, and counting, books that Weinman has written, Ali Karp has been her designer. Both are enthusiastic fans of each other's work.

Page design and book layout is an essential element in helping students and readers access complex ideas. Although in this genre there are easy layout options to fall back on, Karp avoids the cliches and prefers to work with the material in an organic fashion, synthesising fluid and free-flowing designs that compliment and contrast the subject matter without overwhelming it. "It just so happens I love Web design books," enthuses Karp. "The awesome challenge of creating simplicity out of complexity and peace out of chaos is wonderful."

"There is no way a traditional book designer would be able to effectively layout computer books without some knowledge of the material. You must genuinely be interested in the content of a project before you take it on because how else can you communicate the identity of something accurately if you are not naturally interested in it?" she points out. Karp still attends the intensive Web design seminars at Weinman's lynda.com school. "It keeps me on my software toes and allows me to watch the way students interact with the material," she explains, before adding: "In the end I am a better book designer because of it. I am fascinated by the idea that I am able to define the ways a person will both interact with information, and learn something new based on my presentation of the material."

Karp originally met Weinman when she was a student at the Art Center College of Design in the US. "I decided to take a computer class on motion graphics with Lynda Weinman," explains Karp. "Upon meeting her, I said: 'Look, I'm very traditional. I want to be a book designer, I generally hate computer art, and I think these machines are useful only as a tool, and I'm not even sure I want to be in this class!' She replied: 'Fine. Drop the class; whatever.' That was the beginning of a student/mentor relationship that has developed into a long-term designer/client working relationship," recalls Karp. Her attitude to technology has always been one of means rather than an end, and despite being trained as a traditional designer she views the process of design as closer to fine art. "I want to encourage artists to understand that it's possible to merge fine art with commercial art and not lose integrity. You can follow your heart and pursue your dreams while making a living at something that's so much fun you would do it for free."

Karp set up her own studio, Alink Newmedia, straight out of college. "By nature I am an obsessive-compulsive perfectionist," says Karp candidly. "That's why I adore running my own studio; I love being in control. My clients know that I approach each project with one challenge in mind; to clearly communicate information to the end-user. I am currently challenged with combining my left and right brain talents to change the way I run my design studio, and part of that is making the big transition from freelancing alone to incorporating with my new business partner, Adam Griffin. Once again I'm in a learning position. At this point in my life, I giggle at the thought that I had once contemplated law school. Maintaining a balancing act between traditional and digital arts is the most fascinating task a designer can put her mind to. Each project brings a new challenge and always keeps me in a student's mind-set; just when you think you have a handle on it, the future throws out a version 2.0."

<designing web graphics.3>
How to Prepare Images and Media for the Web

third edition

3

Lynda Weinman

0.1 journal

"I keep a visual journal daily to remind me that creativity is possible all the time," explains Karp. "I paste everything and anything I encounter into my journal. It is the vehicle that moves my design projects forward. I refer to past journals for motivation and inspiration and work in my current journal to clearly define my ideas. I have pressed leaves, raw sketches, magazine tear-outs, brainstorming lists, museum brochures, business cards, ticket stubs, receipts, print outs, even love notes. You name it and I've probably pasted it in my journal at one time or another. My little books of montage travel with me all over the world. I am able to trace a client's project back to its origin. Some of the design ideas behind Lynda Weinman's books were developed while on holiday in places like Prague, Norway, Israel and Spain. I am a perpetual student, always reading and researching and studying."

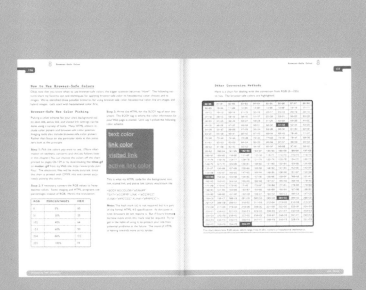

0.2 delivery ↑

"I deliver the Lynda Weinman teaching essence to the end-user," says Karp. "I want the end-user to interact with the books in a comfortable non-intimidating manner. They should feel as if Lynda is in the room talking them through each step-by-step exercise. My goal is simply to be clear and communicate effectively the exact way Lynda teaches in the classroom environment. I want my design to be the invisible vehicle that delivers the Weinman style of instruction; teaching you to teach yourself," she enthuses.

0.3 variations ↓

"It is important to note that each book in the series is its own entity. The book is recognisable as part of a series, however, the specific topic may dictate variations in the design. Weinman's books are ground-breaking in that they're given the special attention that fine art books are. They are not produced like most computer oriented books – by a standard 'assembly-line process' with pre-formatted cookie-cutter templates."

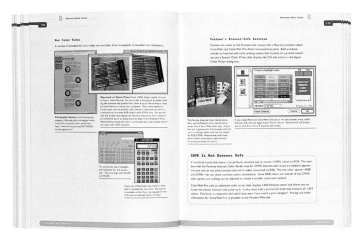

0.4 techniques

"The number one goal of each book is communication, not the design!" explains Karp. "The emphasis is on legibility, not the designer. No matter what design job I am working on, the most important thing is a concept. For Weinman's books I combine traditional design techniques with a Web aesthetic to create the look. Examples of printed pages reminiscent of on-screen ideas can be seen in my nested tables layouts and headlines with an unpredictable HTML feel. However, I choose to integrate the RGB look on to a CMYK page one thing never changes, the design remains quiet, it does not call attention to itself, and it is the aesthetically pleasing invisible container that carries the information," she stresses.

0.5 questions

"Questions I address during the early design stages are; is it part of a new or established series? Who is the specific end-user? What is the latest design trend on-line and is it possible to integrate it into the book's identity?"

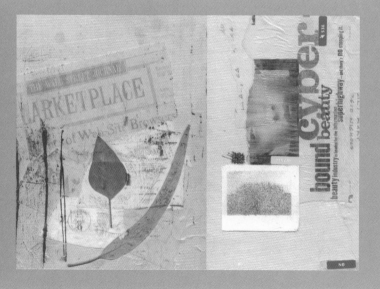

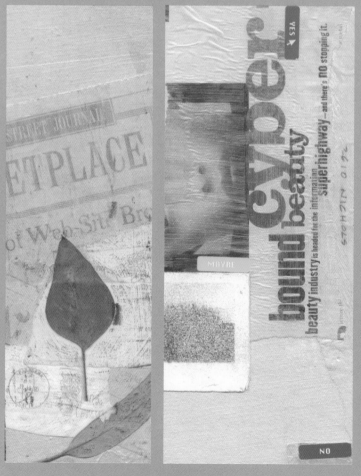

0.6 fonts ↑ ↗

"I combine the 'traditional-print typographic control' with the 'modern-monitor-HTML-lack-of typographic control," Karp explains. "I tend to choose sans-serif body fonts that are practical and objective. I am influenced and inspired by the work of Jan Tschichold, a typographer in the 1920s whose first statement of constructivist design principles put what he termed New Typography, the essence of which is clarity, into deliberate opposition to the Old Typography, whose aim was beauty. Lynda's books demand the utmost clarity because of the extraordinary amount of printed information, which demands the greatest economy of expression. When choosing the head font it's all about rhythm and contrast. I almost always choose a head font that compliments the non-descript body font in a playful manner."

0.7 colour ↙ ↓

"A conservative bigger budget of more colours does not equal better design," insists Karp. "Just because you can take a simple black-and-white pie chart, assign a rainbow of colours to it and place it in 3D space doesn't mean it's going to deliver the information in a clearer way than the original black-and-white 2D pie chart. My answer to the mass-media world of visual bombardment is minimalism; less is more. It's what you can take away, not what you can add."

0.8 colour

"I am most creative when challenged by limitations of a book's budget because I am forced to condense my visions into a subtle whispering colour scheme. In Weinman's books I generally choose a couple of hues from the book's cover art and then play with shades of those hues. The result compliments the intensity of the cover paintings."

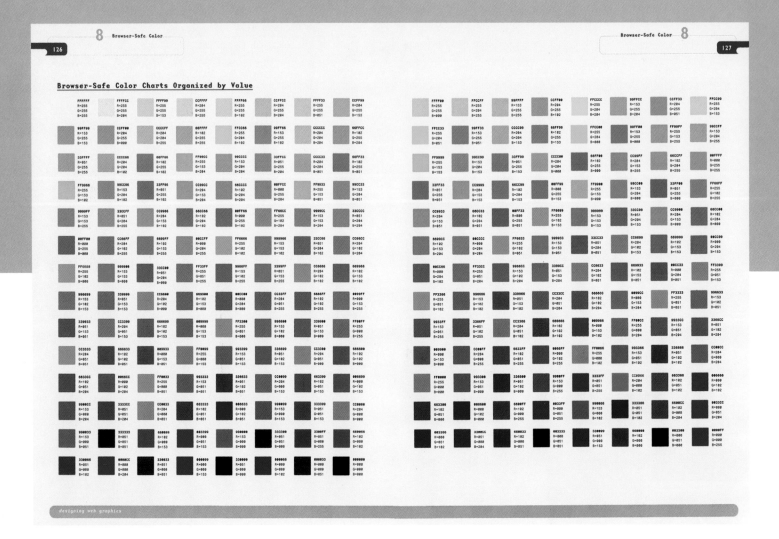

■ site summary

Qaswa

Qaswa proved to be an effective vehicle for the debut of Ammon Haggerty's solo web design studio. Although Ammon recently brought in another artist to help him with some of the work, this should not dilute to strength of Ammon's vision. Rather, one should expect that a synergy could only improve the designs emanating from Qaswa.

- One of the earliest examples of fine web design still remains an exemplary balance of form and function today.

- Although some of the tools are similar today, there are important differences in developing for CD-ROM as opposed to developing for the web.

- Adobe Illustrator can be used as an effective design tool prior to development of the designs in Photoshop.

- The use of icons and symbols, together with well-planned double border GIF backgrounds can add enhanced visual interest to a web site. Adobe Illustrator, coupled with Adobe Photoshop, are the programs of choice for creating such elements for a site.

- The PhotoGIF plug-in for Photoshop helps web designers to create designs that can download in nearly half the time.

- Creating content within Macromedia Director and delivering that content as a Shockwave file with the EMBED tag has brought new opportunities to the web for interactive design and function.

http://www.qaswa.com/

Cooper-Hewitt
Museum on the Web

- ■ Community Building
- ■ Tables for Optimization
- ■ Color Branding
- ■ Background Tiles

http://www.si.edu/ndm/ The Cooper-Hewitt National Design Museum (part of the Smithsonian Institution) is based in New York City and recently celebrated its 100th year of collecting. Elisabeth Roxby was working in the exhibition department at Cooper-Hewitt when the Smithsonian called to say they needed a web site, and she volunteered to meet their two-week deadline. Totally self-taught as an exhibition designer, webmaster and web designer, she has shaped their web presence into one of the most compelling museum sites online. This chapter covers her thoughtful design concepts, her quest for simplicity and purpose, and her thoughts about how web space can add value to the museum space.

Web Design Firm: http://www.roxx.com

Client: Cooper-Hewitt, National Design Museum, Smithsonian Institution

Type of Site: Educational/Informational—Design Museum

Original URL: www.si.edu/ndm/

Server: Silicon Graphics Origin 200 server

Server Software: Netscape Enterprise Server v 2.13

Producer: Elisabeth Roxby

Creative Direction: Elisabeth Roxby

Art Direction: Elisabeth Roxby

Programmer: Rollin Crittendon (special projects)

National Design Museum Webmaster: Elisabeth Roxby

Smithsonian Institution Webmaster: Peter House

Mixing Messages: Curator: Elen Lupton

Technology: Dynamo Developer's Kit 2.0, Art Technology Group

Design for Life Co-curators: Gillian Moss, Susan Yelavich

Website Editor: Julie H. Keisman

Development and Production Platform: Macintosh

National Design Museum Website Coordinator: Barbara Livenstein

0.9 space

"I am a negative space lover and a queen of asymmetry," says Karp. "I am very clear about the white space I designate to each topic and am adamant about limiting each topic to its own page, even if this means leaving part, or even most of the page, full of blank space. I rarely start a new topic halfway down the page, this breaks the end-users' mental flow. My motivation behind allocating white areas is simple; if I were a block of text or picture, I would want my own little area of the page to breathe freely in."

1.0 asymmetry

"Negative space does not sell well to publishers. My style sways towards asymmetry, however, Lynda's style is such that most of the time she requests things to be centred. When it comes to allocating space to the left and right of text and picture boxes, we usually settle somewhere in between. I like to think this gives the end-user a way to distinguish blocks of information such as a step-by-step exercise from a topic or introductions."

1.1 structure

"Each chapter topic should be treated like a miniature book," believes Karp. "Each time I begin a layout, I think 'this topic may be the reader's reason for buying the book.' I usually work with 6–12 columns with at least a pica between each. Depending on subject matter and screen capture scale, the 6–12 columns can translate into flexible one-, two-, and three-column grid structures which work quite well for Lynda's material. I always allow a tremendous amount of space between the spine gutter of my books. This avoids readers having to struggle with important information disappearing into the centre of a book. I also designate a large portion of room towards the outside of the pages. This avoids the problem of a reader's thumbs interfering with the material and also gives them a place to jot down notes."

1.2 dummies

"I mock up dummy samples which include every element in the book." explains Karp. "Lynda's books generally include charts, which I love designing, as well as tips, notes, warnings, movies, step-by-step exercises and graphs. I am always prepared for a last-minute addition to the original plan as long as I have a well-thought out, fundamentally strong concept behind the book's identity. I rarely encounter a problem addressing the design for something at the last minute. I print two copies of the sample with crop marks and trim them. I tape one together like an actual book to judge the legibility and aesthetic. I tape the other sample as spreads all over the wall of my studio to judge the sequential narrative flow. I also carry a sample around for a couple of days to take to friends and family; real-world individuals whose opinions and judgement I trust. Lynda and I go back and forth via e-mail and print-outs in order to make the final adjustments."

Lynda Weinman, Designing

comments

project credits

Author Lynda Weinman

Designer Ali Karp

Cover Artwork Bruce Heavin

Publisher New Riders Publishing

www.lynda.com

www.digitalartscentre.com

Ali Karp – Alink Newmedia

E-mail alink@earthlink.net

Web Graphics.3's author

Lynda Weinman, author

Lynda Weinman began her career working in video, special effects, multimedia and animation. She got into writing by accident. Speaking at a design conference she was approached by an editor who asked her to write a piece for a magazine. The article was well received and Weinman's writing career snowballed from there. Her first encounter with the Web didn't inspire her, however, after some time she began to realise its potential and was then curious about how to create content for the new medium. "I went to a bookstore to find a book about how to create the Web graphics," explains Weinman, "but that book didn't exist! With my new-found writing success, I decided that I could write a book if I had a publisher's backing. It was hard to get a book contract, so I started writing magazine articles that helped me research the Web subject matter. I was a teacher at Art Center College of Design at the time, and I started offering Web classes there, in addition to the classes I was already teaching in motion graphics and interactivity. This also helped me with research for my book. Eventually I landed the book contract and the book came to be Designing Web Graphics, now in its third edition. It was an instant bestseller, and 13 books later I am still in love with the medium of book writing." It was while teaching at Art Centre that Weinman first met Ali Karp, a student in her motion graphics class.

Weinman's pedagogic stance is to treat students as artists rather than technicians. For her books she draws on her experience as a classroom teacher. "Readers want to know what they have to know," she says, "and they especially like practical advice and techniques that work in real-world situations. Some people are passive learners and want to read all about something before they try it while others are active learners and need to try something before they can understand it. I have been teaching constantly for the past ten years, so I have developed lots of different teaching devices for each subject." Consequently Weinman's writing style is relaxed and open but doesn't shy away from technical details and code when it is necessary. It eschews using buzzwords or dull manual-like text and concentrates on accessibility and pragmatism, allowing readers to incorporate the topics covered directly in their own work. This easygoing approach is directly reflected in Karp's designs and layouts. Perhaps this explains their continuing successful relationship over 13 books.

project 1.1 earthwatch

The current convergence of so many technologies – television, internet, radio, WAPs, to name just the most well known – is having a profound effect on more than just the hardware and associated applications. Inevitably, content is changing to exploit the growing opportunities offered by interactivity, but it's also changing in its definition and structure; edges are becoming blurred as marketing, commerce and editorial merge. A music programme offers the opportunity to buy a featured band's album at the press of a button... does that compromise the editorial content? Marketing originates dialogue between the creator and user... is the result advertising or editorial? One recent project from London PR and marketing consultancy Foresight is an intriguing example of such marketing /editorial crossover, and because it is driven entirely by original content I have decided to include it here as one possible route for the future of editorial Web design.

Foresight can trace its success in the new media arena back to 1995 and the creation of an independent trailer website for the ultra-trendy Pulp Fiction. An early success in the burgeoning world of internet marketing, the site played a part in catapulting the tiny new media/interactive arm of the company into its fastest growing department, with an impressive client list that encapsulates many types of business; from Paul Smith, Cerutti and River Island to Interflora, Bob The Builder and The Early Learning Centre. But it's the work for two particular clients – film trailer sites for Twentieth Century Fox and Buena Vista – that really stand out in design and innovation, and it's the design and content of one site, Earthwatch, by interactive designer Peter Hamblin, that has garnered the most praise from design and marketing circles.

Earthwatch was devised as a site promoting last summer's animation sci-fi movie Titan AE (the 'AE' standing for 'after earth'). The animated feature mixed computer imagery with classic animation techniques to tell the story, voiced by the likes of Matt Damon, Drew Barrymore, Bill Pullman and Janeane Garofalo, of earth's destruction at the hands of the evil Drej, a warlike race headed our way from the other side of the universe.

Foresight and Hamblin's UK-specific site, called Earthwatch to differentiate it from its much more traditional trailer US counterpart at www.titanae.com, acted as a fictional prelude to the theatrical release of Titan AE which incorporated daily news from around the galaxy, contained clues and hints to the storyline of the film and provided key pieces to the puzzle that leads to the destruction of earth. Organised as a newspaper or news service, the Earthwatch site wittily sends up and undermines big corporations and their obsession with marketing and branding, made up as it is of myriad typefaces and logotypes, satirical news stories and lots of tongue-in-cheek branding; all fictitious and all striking.

Designer Peter Hamblin, responsible for every element of the site, came to Foresight in 1998 as a graphic design graduate and RSA runner-up for a virtual art gallery. His first task was the design of a touch-screen kiosk interface, but his lack of interactive design experience – "a four-day HTML course and a bit of Director and Flash" – did not prove a disadvantage: "Those are things you can learn in order to make the idea you have work. What's important is the grounding in design; you can take the rules governing design and adapt and apply them to anything," he says emphatically. "Some people think it's more appropriate to come to interactive design from an IT background, but I don't agree; IT people look at things from a technical perspective, whereas designers are taught to think about the overall view; it has to look nice, work well and present a complete package," he adds. There's no doubting that Earthwatch does all of those things and, combined with the original content, offers a project that stands out on the internet as a great piece of editorial/marketing crossover.

0.1 planning ↑ ↗ ↘

Earthwatch website designer Pete Hamblin explains the structure for a new job on page 143, and part of that structure is sketching, which forms an integral part of any concept in its early stages: "I think designers do a lot of things by instinct, that's why we're designers, not printers or programmers. The more important/difficult thing is the thinking behind a project to immerse yourself into its context," he says. From the beginning, Hamblin planned pages for Home, Weather, Holoscopes, Reporters and Archive, along with alien pop-ups and ads, as the site was meant to act as a 31st-century news portal, with all the elements one would expect to see on such a site.

0.2 brainstorming ↑ ↴

Hamblin brought in freelance writers to develop the witty news stories that hint at earth's imminent fate: "They started off as very funny but got much darker as we neared the movie's launch date – or earth's end," explains Hamblin. The writers received a general overview and background to the film and content, along with information about Earthwatch and what Hamblin aimed to do with the site. "We held a number of brainstorming sessions with designers, art directors, writers, project managers and account handlers, which mostly consisted of seeing what made us laugh. The writers had a lot of questions to ask on the details of the information they had received, and we tried to fill in the gaps. At this point the design of the site was far from finalised and these sessions gave us the sounding boards I think both groups of people needed to really understand the world in which the site was set. We also gave pointers as to the kind of feel we wanted by referencing other works – The Hitchhiker's Guide to the Galaxy, news sites, sci-fi writing by Jeff Noon and Neil Gaiman, films like Robocop and Starship Troopers," recalls Hamblin.

0.3 influences

Hamblin's initial ideas for the site's design drew on two areas; his love of 1970s' sci-fi movies and graphics, and a job with a company based in Elstree Film studios. "While there I saw a sign for one of the stages written in huge letters above a doorway in something similar to Eurose/Eurostile. It was just a number, but because of its height and the narrow gap between the buildings it had a kind of futuristic appearance. It looked like something out of Space 1999, or Thunderbirds," he recalls. "I used it on Earthwatch because the connotations I had about the typeface in my mind (the association with 1970s' sci-fi) seemed to fit with the kind of 'ironic-cool' we wanted to achieve for the site. I tried to do the same with my own titles. The page headers were developed using simple shapes and curves. I experimented with line widths and corner shapes, but I decided to keep it simple. The boldness of the type was developed to add weight to the title, so that people would take notice of it."

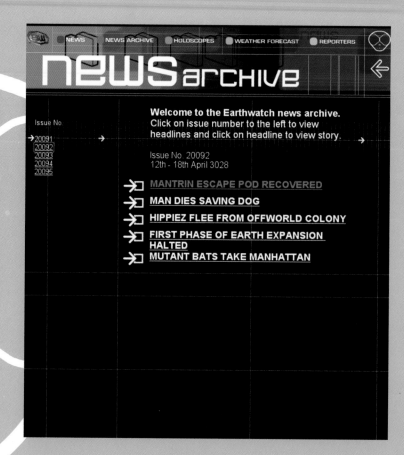

0.4 colours ↑

For the retro feel that Hamblin wanted for the site – "the kind of science fiction we imagined in the 1970s; Charlton Heston in Planet of the Apes mixed with the simple graphics of Manga" – colour was all-important, and the Verner Panton-like colours and shapes succeed in calling to mind that decade, but with a futuristic twist. "We chose warm, friendly shades, especially for the home page, to welcome people into the site. Different colours were used on each page to differentiate the sections, and also section colours were picked to match the content of the page. E.g.: weather = green = environment. We went with flat colours because they load more quickly than photographic images of high quality, but the flat colours were also a design decision. I wanted to use the headers and the site's design to set it apart from the print and cinema/television campaign, which was quite cinematic and glossy," explains Hamblin.

0.5 content

"We did a lot of thinking while developing the content for the site which didn't make it into the final product for different reasons (mainly financial): One idea was to develop a number of intergalactic 'mega-corporations' to sponsor or own different areas of the site. The idea was that in the future, companies would own whole branded planets and countries, a theme that runs through a lot of cyberpunk and science fiction work. There would be entire areas of the galaxy run by corporations rather than governments. So we started to develop these corporations into more concrete ideas like 'Sosumi' i.e.: So sue me, a giant company based on the Japanese corporations in the book Rising Sun by Michael Crichton. Astar is a telecommunications company, also of Pacific Rim origin, while Meggalarge Newscorp is a corporation whose inspiration came from the film Robocop and its firm Omni Consumer Products."

PORTAL SPONSORS THE EARTHWATCH WEATHER PAGE. GIVING UP TO THE MINUTE DATA FROM THE GLOBALNET WEATHER CONTROL SYSTEM

MIRACOM

SOSUMI

UNICORP

INFRARED IR

Incoming GalacticRelayStation Message
GRS

ASTAR

MEGGALARGE NEWSCORP

PORTAL
OPEN THE GATES

0.6 originality

Where a film trailer would normally have to centre around clips and a preordained range of content such as cast and crew biogs and a synopsis, Earthwatch, created with "total freedom in terms of content and design," could act as an inventive spin-off that promoted the film in a more original way. Hamblin created a site which aped newspapers or news sites, using a number of features found in them, including monthly holoscopes. "Film sites are not usually kept up to date for long periods, because they're used as a marketing tool by distribution companies to get people to watch a film, then discarded as the responsibility and rights to the content of a film change hands when the film is released on DVD and video. But with Earthwatch, we updated until the film was launched, because the idea was that the site act as a real-time news site until the earth's destruction, five minutes into the film. So if you look at the site now the holoscopes page has 'your last holoscope – the future is bleak' as a title. And the stories lead with 'Earth – Destroyed'."

0.7 avatars

The helpers – Hamblin's favourite design element on the site because "they were the most fun to do" – were hand-drawn before being worked up in Illustrator and animated in Flash. "I wish I'd had more time to develop them," says Hamblin. "They are essentially like the avatars you get in Microsoft Software; designed to give information and point users to new areas of content. Their full functionality was never implemented due to time constraints, but one of the things they were meant to do was sell things to users. They were subversive advertisers who might hold up a placard with a company logo on it, or be seen using certain products. The idea was that even in this independent publication, the influence of the mega-corps was never far from the surface."

0.8 weather ↙

Another area that was designed and developed but never implemented was the weather section. "It's an idea we should probably sell to IBM or someone, but it was to do with the concept of a global weathernet which could control the weather conditions everywhere on the planet. The populations of different areas could vote for what kind of weather they wanted, which of course would also lead on to news stories and lines of debate; for example, the entire population of Southern Spain always wanting it to be sunny would cause desertification and other environmental problems on the Costa del Sol. There was also to be a storyline based on the abuse of the weathernet by eco-terrorists who were holding areas to ransom with threats of floods and hurricanes. The terrorists were back-to-basics people who wanted mother nature left alone." Sadly, the sheer scope and level of functionality it would have needed meant it couldn't be incorporated in such depth, instead offering a more basic weather page and sponsorship concept.

SECTOR 1
SUNNY SUNNY SUNNY
THIS IS LOVELY WEATHER!

SECTOR 2
RAIN FOLLOWED BY MORE RAIN
25% CHANCE OF GALACTIC STORM DAMAGE

SECTOR 3
ASTEROID SHOWERS AND METEOR
INTERFERENCE AT 32%

SECTOR 4
SUNSTORMS AND WIND SHOWERS 50%

1.0 community ↓

1.0 community

The content for the site centres around the original news stories, and Hamblin also planned to build a community for 'reporters' that tied into a site section of the same name. "The idea was that people would be able to submit their own stories, the best of which would be edited then put up as news stories," he explains. Part of that was to be a creative writing project for school children, but this never materialised due to contractual problems.

0.9 software ↑

Earthwatch makes ample and innovative use of Flash, JavaScript, CGI, Swift and Director. Its main pages were created as vector files done in Illustrator, with all copy embedded within the Flash movie. This gave Hamblin a free reign with body copy and five custom-built title fonts, along with four more for banner ads which appeared on other sites and were built using Adobe's ImageReady.

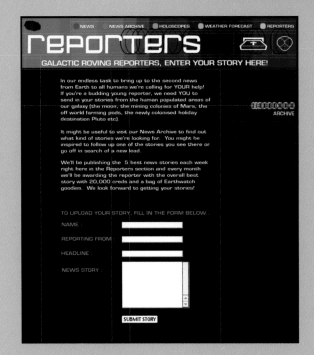

Peter Hamblin, Earthwatch's

comments

project credits

Designer Peter Hamblin

Project Manager Brigid O'Connell

Art Director Alex Galle

Marketing Manager Paul Louis

Foresight (Europe) Limited

Beaumont House
Kensington Village
Avonmore Road
London W14 8TS
UK

T +44 (0)20 7348 1000
F +44 (0)20 7348 1110

www.foresight.co.uk
E-mail info@foresight.co.uk

designer

Peter Hamblin, designer

The initial work on any design project is often overlooked when people talk about design and creativity, but those first stages are crucial not just to the smooth development of ideas, but also to a good working process and a good relationship with the client. Here Peter Hamblin outlines these early steps:

Presentation

"Once we've been invited or decided to pitch for a job, we will spend a couple of days preparing 'mood-boards' and identifying target audience, purpose of project and so on. We'll then present our ideas and the boards, which aren't indications of how we will design the product; i.e.: they won't look like a finished design, but aim to give a 'feel' for the project. They'll include elements of brand and positioning, imagery and colours, which is especially important to give the board and project an overall feel."

Initial Designs

"Once the job's been won, we hold brainstorming sessions with all the people involved in the project. We decide on a direction and how best to accomplish what the project's aims are. At this point we start to lay down rules for design, such as branding, although we try to leave this as open as possible to enable the best/most creative approach to the project. Then the designers start to develop concepts for the design of the sites. These will be constantly refined, because they're being created in the studio environment with lots of creative people around giving feedback."

First Presentation

"After the initial designs are ready, they're presented to the client to get a design direction. It's likely that we'll present a number of different concepts, using laptop/projector presentation, sketches, boards and notes. It's rare for the client to be a hundred per cent happy with the result at this stage, so we'll usually have to take elements from different designs to develop into a product that client and designer are happy with. Because this is a critical stage in the development of a project, and clients can be quite forceful, we present our ideas, never show them via post or e-mail."

Build

"Once design has been signed-off by the client, build work can begin, with designers and Web developers working in conjunction; the developer coding pages and functionality in the most elegant way possible, the designer on hand to give direction. In many cases we will develop a 'guide to design' for a project, detailing sizes, colours, typefaces, sizes, kerning and leading. Once all the build work has been completed, a website will get tested on as many different platforms and browsers as possible, or within the target user group of the site. Then, bugs fixed and everyone happy, the site goes live."

project 1.2 my BBC

The BBC has an unmatched reputation around the world as the epitome of public service broadcasting. Pioneering radio and then television during the last century, the public service body is doing the same with the internet this century, and currently runs one of Europe's largest and most visited websites at www.bbc.co.uk. Covering all the BBC's key areas of output from news to education and soap opera to sport, the site is largely structured by programme genre rather than as a series of channels, reflecting the television or radio output.

All broadcasters entering the new media arena have to make decisions about the relationship between their products on different platforms and what effect the medium has on the relationship with the viewer or user. For the BBC, giving as wide as possible access to its content to as many people as possible remains a core requirement. Looking forward to the digital multichannel environment that will exist around its products, the BBC has started work on customising and personalising the way that people can access their products. My BBC is the first such product.

The immediate starting point for the project was a number of internal outline documents addressing the issue of personalisation. As designer Neil Clavin describes: "We had to develop the project from a base made up of two important documents: a Personalisation Business Plan (Editorial Proposition) and a more detailed launch plan. BBC On-line wanted to offer personalisation to improve the user experience and increase loyalty and usage of the BBC site in line with the growing popularity of personalisation in portal sites. Research revealed that 19% of BBC On-line users had already personalised a site such as Yahoo or Excite."

"The objectives of offering personalisation would be threefold: to attract those users who are looking specifically for a one-stop shop of aggregated content; to turn occasional visitors into regular users; and to get them visiting more often and to build a deeper understanding of the audience in order to move closer to a one-to-one relationship," says Clavin.

"There are three main routes to personalising an interactive product," says my BBC executive producer Tony Pearson. "There's customisation. Essentially users tick boxes to opt in or opt out of specific services, content or features and they get served what they want each time they visit or use the product. The second route makes assumptions about users based on knowledge about them. So users will be fed material depending on their age, sex and so on. The third method, collaborative filtering, is based on analysing what people do within a site, rating that usage and feeding it back to users. This might be expressed in the form of a message: 'People who liked this section of the site also visited such and such an area of the site'."

At this stage of its development the project reached across all of the BBC's on-line output from the different departments such as News On-line, Broadcast On-line, Sports On-line and the World Service. The intention was that it would be Web-based and would be easily transferable in the future to any Web-ready platform.

The brief stressed ease of initial set-up to the service. This would mean speed of registration for new users and comparing time taken to register and so on to a benchmark such as Yahoo! or Excite. Similarly there would be the auto creation of default my BBC pages according to a user's 'passions', such as news and football or cricket. It would consist of a single page, be simple to use and would differentiate itself from the standard BBC home page. Compared to many personalised portal sites, one of the great advantages of the BBC page is how easy it is to update and change one's settings.

The final stipulation of the brief was that at launch there would be no specially created content feeds; the project would rely on existing material already in existence. This would vary in format from video of BBC news programmes and text headlines to weather reports and what's on guides such as the television and radio schedules.

Personalisation will play an increasingly important role in Web design, eventually becoming as integral to it as choosing colours and planning a site's navigation. For that reason we have focused on that personalisation element in the my BBC project, rather than take an overview of the entire site design.

modules of personal value are encouraged and fed more information-
becoming of greater value.

modules of liitle personal value will be neglected and may be discarded
by the user to make more room for those of value

0.1 on-line personalisation　　↑　　↗

"After reading the brief I felt that I needed to conduct further research into the area of personalisation. This consisted of searching the internet for articles describing the pros and cons of personalisation and case studies of successful and unsuccessful implementations," says my BBC designer Neil Clavin. He spent several weeks using sites and services such as my Yahoo!, my Excite, my CNN, my Altavista and my Lycos as a way of getting a deep understanding of the project. From this research he noted "which features were useful, which annoying, which counter intuitive, which elements could be kept and re-applied to my BBC and which should be avoided at all costs." As part of the development process Clavin produced a series of presentations that encapsulated a broad approach to the process of personalisation from the user's perspective. Here a window-box to hold flowers is used as an example. As the on-screen text explains, the user can "arrange the modules as they wish." Or even "arrange the containers as they wish." From these experiments Clavin developed the idea of the modular nature of on-line personalisation.

0.2 functionality

At this point certain key decisions were taken that would shape the functionality of the site and would be reflected back in the way users related to personalising my BBC: These were points 0.3 to 0.5, as follows.

0.3 info panels

To make the process of adding and moving 'info panels' to the user's page as simple as possible, with an interface that would represent the user's page and be easily understood.

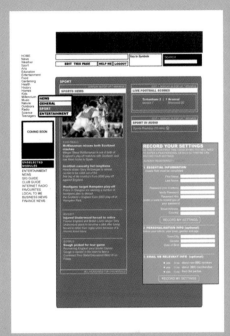

0.4 editing

All editing should take place in separate pop-up windows rather than in the main window. This would mean that the user would always be able to see what they were editing, meaning that they did not have to remember a possibly complex mental model of what their page looked like or what information was currently on a particular info panel. It would also minimise mistakes while editing the page.

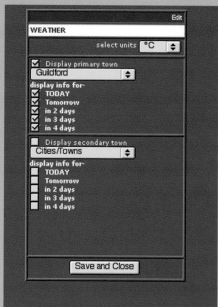

0.5 naming

That all info panels should be carefully named to concisely describe their content and be consistently referred to by the same name throughout.

0.6 consistency

The first design schemes that were produced don't differ greatly from the designs that finally made their way on to the website. The main attributes are around clarity, both in how the elements appear to the viewer and also in how they're actually arranged on the page. Similarly it was regarded as essential that the tools to modify and grow a user's personal page would remain as consistent as possible.

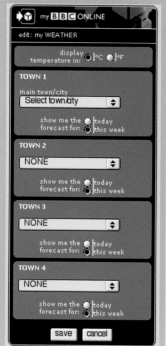

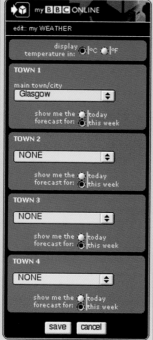

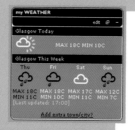

0.7 user testing

The BBC tested alternate designs on small groups of users to see if the beliefs they had about how people would use the service were borne out. The testers were chosen because they each had around six months' on-line experience, which was felt to represent a median group. The testers were shown the designs and asked what their expectations would be around particular parts of the design. So, for example, a question might be: "If you clicked on this link what would you expect to appear?" Similarly the team tracked the ease or difficulty that the testers encountered in the registration process or in following a particular story from my BBC (where it appears only in summary) through to the full story on the BBC's news on-line site and back to my BBC. For Clavin this real-world testing gave him the framework to finalise the look, feel and structure of the site based on actual experience rather than just on educated hunches.

0.8 customisation

The final my BBC website allows a range of customisable features, from choosing what area the weather report covers, to which content modules the user is interested in. Here, using the pop-up control window, the location of the weather report is altered from London to Glasgow and from a one-day view to a four-day view. Ultimately, the my BBC project has two striking aspects to it: the thinking and research that informs the design work in terms of the product's relationship with the user and also the technical implementation of the products objectives. Reflecting on the design/functionality/technology relationship, Clavin says: "They are the skin, bones and muscle of the product. For the designer not to become a de-skilled 'decorator' of interfaces, he or she has to take responsibility for the functionality, usability and information architecture of the project. As with architecture, the designer must understand and integrate surface, structure and mechanics in a harmonious and supple manner in order to produce a beautiful and efficient product."

0.9 colour

Another aspect of personalisation is the ability to alter the colour schemes of the page using another pop-up control window. While changing the colour scheme may seem less significant than altering the actual content, it does have a real value in terms of personalisation. As Clavin explains: "After examining the current landscape of personalisation, I thought: 'if nobody had ever done this before, what models already existing in the real world would we use to inform how we might design a service a user could personalise? I took in everything; from the very basic product level I looked at things like mobile phones, which allow the user to customise ring tones and covers, through to the subtle details which make things like the iBook more personal and friendly. I also felt that much current advertising reinforces this idea of individuals in control of their lives and environments. I then thought about some of the more low-tech things people do to personalise themselves and their environments, things like: putting their name on something; use of colour (clothing, houses); use of positioning of objects e.g. a mantlepiece, plants in a window-box; use of texture in things like clothing and furnishings; use of images in posters, stickers and badges."

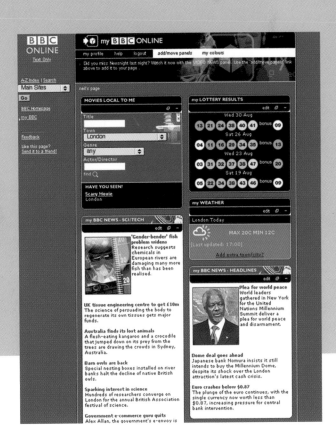

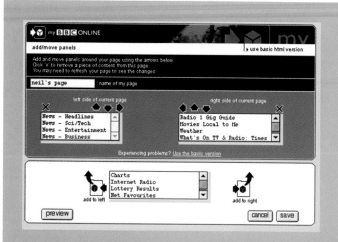

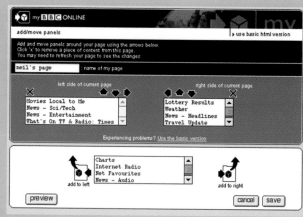

1.0 customisation

In the look of the website, as well as being able to control the colour scheme, users can alter the layout and customise it to a high degree to reflect their specific interests from the content on offer. Having looked at how people customise spaces, Clavin went on to think about why people do it in the first place and what the value is to them, or "what is the payback to personalising?" To make personal property more quickly identifiable as their own (painting your front door red); to express their own interests to others (wearing a football kit); to focus their interests by filtering out things they don't like or are disinterested in. "Finally," continues Clavin, "I thought about what makes people feel that something is personal, and decided that it's that it belongs to them; that they have complete control to do what they like with their property; that they can 'see themselves in it'; that the object that belongs to you remains as you left it, e.g. if you stop reading a book when you come back to it you will see the same page you left."

1.1 framework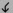

The current version of my BBC has successfully developed a route to customising the presentation of the BBC's on-line content within an open and flexible framework. The next stage of development includes developing my BBC for other platforms, including mobile devices and rich media versions like television and audio. Using the Avant Go technology that allows news and information content to be delivered via the Web to PDA devices, the BBC has planned to port my BBC to the Palm hand-held. Here personalisation would give added functionality such as allowing users to request particular packets of information like a certain day's lottery results or advance weather reports. Clavin is extremely excited about the possibilities offered by expansion into these areas: "The idea of my BBC on mobile devices is especially exciting because ultimately it brings the means of personalisation much closer than ever to a person's daily life and routine."

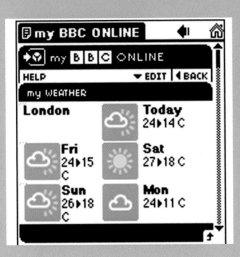

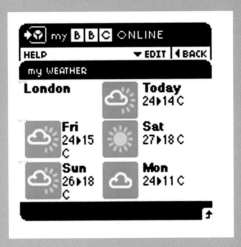

Simon Brickle, my BBC

comments

project credits

Designer Neil Clavin

Development Team Leader and Project Manager Simon Brickle

Project Manager (until May 1999) Steve Pitman

Art Director Neil Clavin

Perl developer Mark Hewis

Perl developer Jon Antonovics

Perl developer Andrew MacInnes

HTML developer Andrew Bowden

Editorial Supervisor Tony Pearson

www.bbc.co.uk

website's project manager

Simon Brickle, development team leader and project manager

"The project team comprised a project manager, development team leader (myself), three developers, a designer and an HTML coder. The initial planning phase took place prior to my involvement in December 1999, meaning a 'rough requirements' document was available when I started. My initial tasks were to work this into a more detailed requirements definition, while recruiting the developers. By January 2000, with the development team in place, we set to work on detailed design, an activity in which all the developers were involved. Team members presented their designs to the group, who reviewed, criticised and modified ideas as necessary."

"The two technical challenges facing us were: firstly, to combine data feeds from a range of different sources into a common output format, and secondly, to make a system that would work in a distributed manner, where modifications could be made from any of the three different BBC server locations. In the event, the second of these became unnecessary, when a decision was taken to install my BBC on a single machine only, and defer the distributed architecture. Unfortunately this came after the problem had been effectively solved, at considerable expense."

"The first problem was solved by abstraction. The system is implemented as two 'layers', running on separate machines. The lower level, the data-collection layer or 'staging server', runs a 24-hour template building operation, gathering data files from around the BBC server infrastructure and templating them into HTML code fragments. The presentation layer, or 'content server', identifies users via log-in or a user ID cookie, and pieces together the user's page from the HTML fragments built by the staging server. Because a great many operations are involved in building a page at run-time, a content server would have been extremely slow but for the decision to use mod-perl. This Apache server module runs permanent perl processes, in a manner similar to an application server, allowing common tasks to be performed once, and heavy data structures to remain in memory, for cacheing and to reduce script load times."

"Future developments are planned, and, apart from tying up loose ends and rewriting the scrappy bits, they include new panels (football teams, learning journeys, international weather... the list keeps growing) and new platforms (PDA, Web on television, games consoles, embedded pages etc.). The best thing about working on it was the speed of development – it was the most impressive thing I've ever built, and it took seven months from start to finish. None of us is quite sure how."

acknowledgements

In the digital age it can be argued that communication becomes easier, ideas and original thought harder. As many of these interviews were conducted primarily via e-mail I worried that less of the contributors' thoughts and personalities might survive crossing the ether; in fact each of them worked hard to achieve the opposite and supplied copious and detailed text on their projects and their way of working. I'm hugely grateful to each of them for their unflagging openness and willingness to share their knowledge, experience and creative processes.

Thanks too must go to my unflappable editor Natalia Price-Cabrera, my co-writer John Cranmer (who wrote the chapters on the Tate and wallpaper* websites and 'Designing Web Graphics 3') and the always patient and totally-on-top-of-things designers, Chris Kelly and Gavin Ambrose at Mono. Their professionalism, enthusiasm and design solutions to a work in progress were much appreciated.

And last but not least, thanks must go to all the people who gave me moral, physical and spiritual support. And lots of beer. They know who they are, but will be well pissed off if they don't get a mention. So big thanks and love to Paul Murphy, all at catfunt, the Time Out TV section, Don Cornelio and my family, Egidio, Maria and Vince Zappaterra.